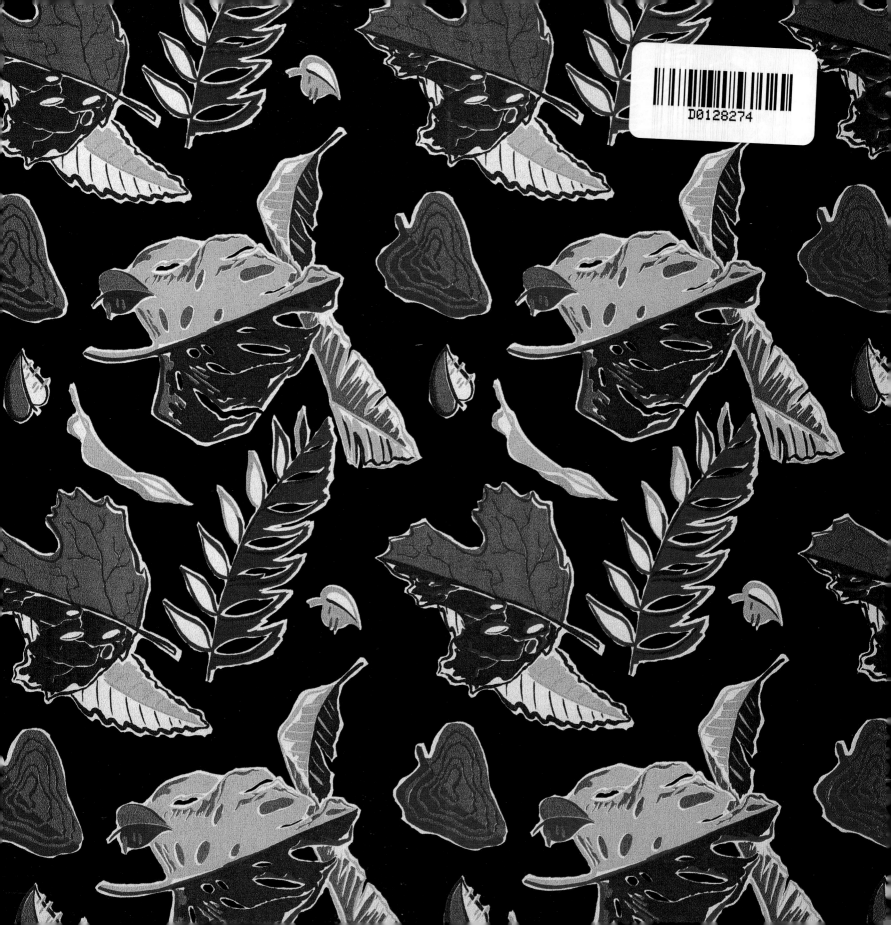

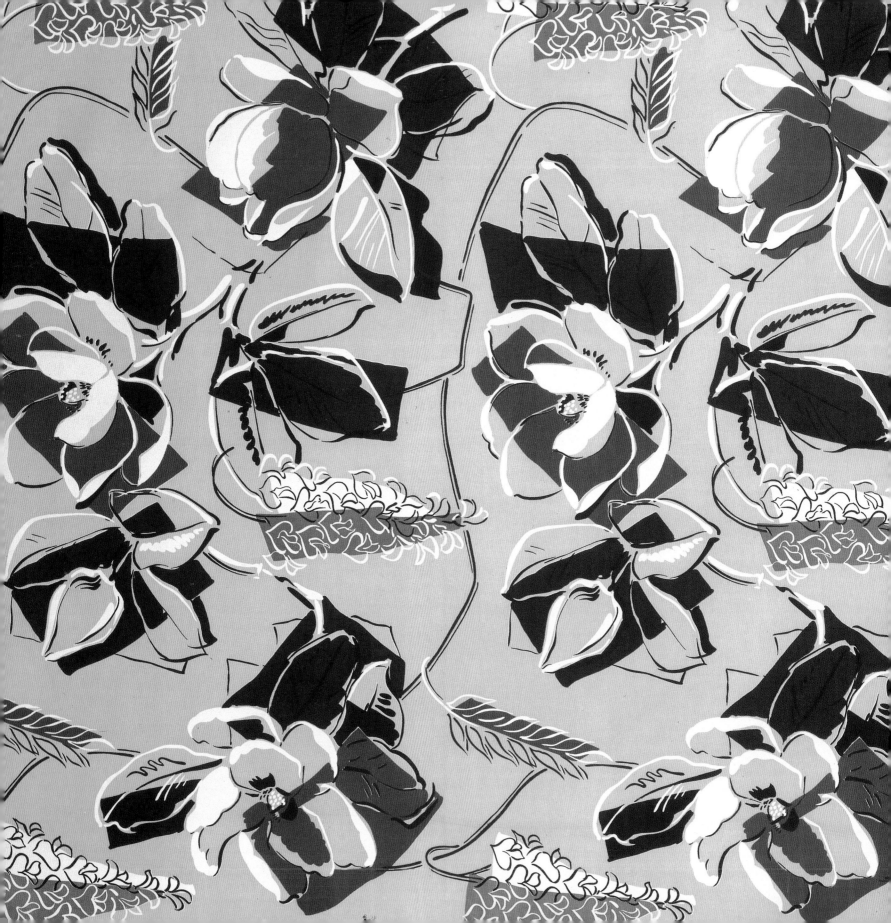

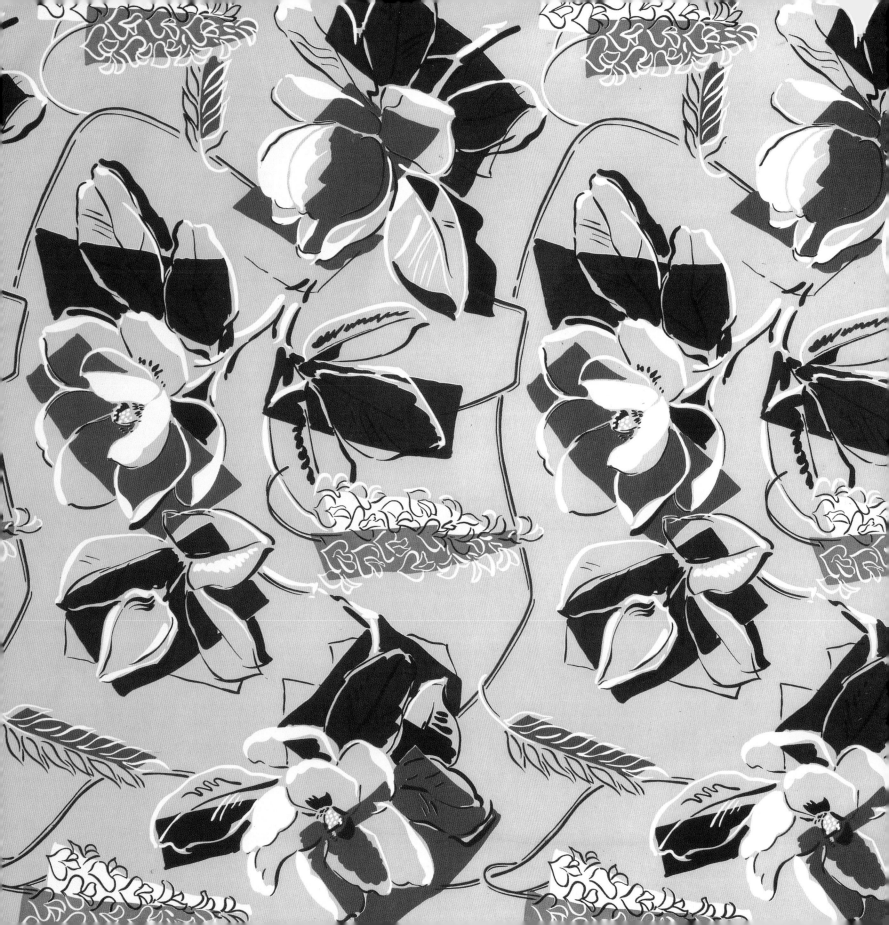

Fabulous

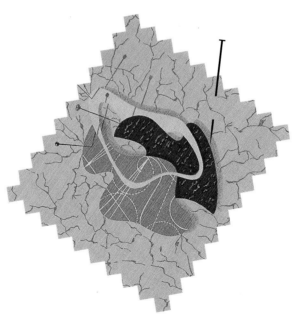

Fabrics of the 50s

(And Other Terrific Textiles of the 20s, 30s, and 40s)

Gideon Bosker • Michele Mancini • John Gramstad

Photography • Gideon Bosker • Bruce Beaton

Chronicle Books • San Francisco

Printed in Hong Kong.

Library of Congress Cataloging in
Publication Data

Bosker, Gideon.
Fabulous Fabrics of the 50s (and other
terrific textiles of the 20s, 30s, and
40s)/by Gideon Bosker, Michele
Mancini, John Gramstad: photographs
by Gideon Bosker and Bruce Beaton.
 p. cm.
ISBN 0-87701-811-1 (pbk.)
1. Textile fabrics—United States—
History—20th century.
2. Drapery—United States—History
—20th century. I. Mancini, Michele.
II. Gramstad, John. III. Title.
NK8912.B67 1992 91-36656
677—dc20 CIP

Editing: Judith Dunham
Book and cover design:
Michele Wetherbee

Distributed in Canada by
Raincoast Books, 112 East Third Ave.,
Vancouver, B.C. V5T 1C8

10 9 8 7 6 5 4 3 2 1

Chronicle Books
275 Fifth Street
San Francisco, CA 94103

Table of Contents

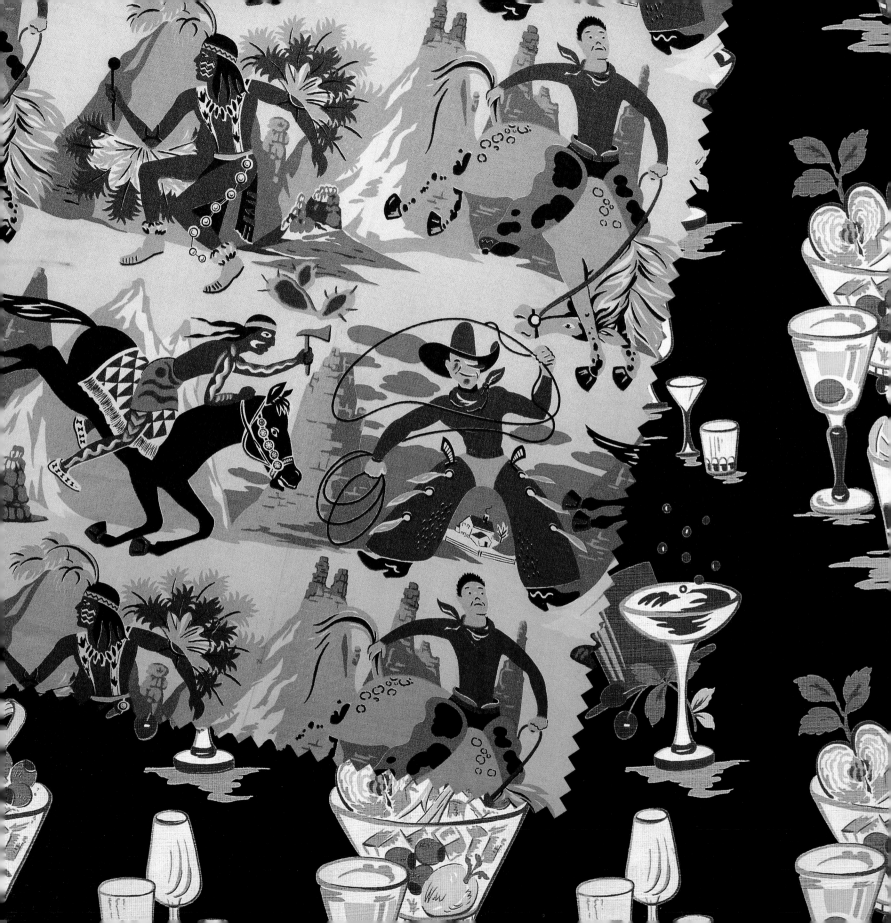

M ore than anything, the first five decades of this century were the curtain years. From the sinister, metaphoric Iron and Bamboo Curtains that cleaved East from West, to the maniacally pigmented barkcloth curtains that slathered picture windows of tract homes during the soothing Eisenhower years, the fact is twentieth century America has been obsessed with curtains.

In many respects, the history of the American curtain can be seen as a Rorschach test of trends and milestones in American design from 1910 to 1960. Until the freewheeling, let-it-all-hang-out ethos of the 1960s stripped windows bare in the homes of the chic across the country, a living room without curtains seemed shockingly naked, transitional, and, most of all, unfinished. Even in the meanest big-city tenement, curtains connoted security, privacy, and respectability. And, thanks to mass-production techniques and a plethora of regional textile mills spinning miles of yardage in low to moderate price ranges, drapery fabrics imprinted with tasteful patterns were readily available to a broad spectrum of the population.

When it came to taste, however, curtain textiles were not about high style or elite aesthetics. Like other consumer goods for the masses, these domestic appointments reflected popular notions of good taste as they were promulgated in illustrated magazines, decorating guides, and, increasingly, the Hollywood cinema. For the most part, fabric patterns produced between 1920 and 1960 kept pace with prevailing developments in architecture, interior design, and technology. In tune with America's mood of isolationism in the period between the two world wars, curtain patterns were not oriented to European trends in textile design. Nearly absent from American textiles from the 1920s, for example, are the geometricizing influences of Art Deco.

Instead, the 1920s furnished traditional floral patterns and subdued geometrics. During the 1930s, a vogue for tropical motifs began to emerge, along with a tendency to combine floral and geometric

patterns in a single print. Curtain fabrics from the 1940s were rich in figural, regional imagery and responded to the war effort with a subdued palette of colors. By the end of the decade, a distinctive transitional style surfaced, providing a crossover from representational florals to abstract geometrics. By the early 1950s, the modernist aesthetic, with its penchant for clean lines, bold colors, and form-follows-function dogma, became the rallying cry for the masses. Americans embraced modernity as a new gospel and rushed to deck out their homes with curtains broadcasting icons of innovation: images of atoms, cell structures, automobiles, satellites, and television sets.

For most of the midcentury period, no middle-class home was secure without yards of pleated drapery slung across acres of glass to shield nuclear families from the outside world. The edginess of atomic living even spawned an entire genre of "duck and cover" civil defense films that featured butch-waxed daddies closing curtains as a first line of defense against deadly clouds of nuclear dust. With their atomic splashes, Gauguin-esque florals, and science-lab geometrics, American curtains of the mid-twentieth century featured a variegated parade of amoeboid shapes, magnolia petals, and cabbage roses marching over cloth. The more representational fabrics from this period sported south-of-the-border regional scenes, robotlike mannequins, and icons of popular culture, from circus clowns to cowboys. On the surface, these textiles pulsated with colors so rich and offbeat in chromatic range that they frequently seemed to have wandered off the Pantone color chart. But beyond surface frenzy and tropical motifs, these prosaic domestic appointments also popularized and disseminated an abstract vision that came from the design studios of Jean Arp, Alexander Calder, Frank Lloyd Wright, Joan Miró, and Salvador Dalí.

Although the most interesting midcentury fabrics featured designs inspired by architects and artists working at the more rarefied end of the visual arts spectrum, this did not prevent them from achieving

widespread acceptance. At an original cost ranging from $1.98 a yard for humble barkcloth, to $6.98 a yard for "upper end" satin damask, these textiles eventually trickled down to homes on Main Street, U.S.A. Barkcloth was a generic household term of the period used to describe the nubby, barklike texture of cotton curtains made from a twisted two-ply weave.

In one important respect, these textiles might best be decribed as "ironic curtains." Both in the past and in the present, novelty draperies have performed the symbolic function of signaling the owner's social prestige. In the first half of the twentieth century, these relatively cheap textiles made the tastes of the affluent accessible to those aspiring to higher status or to greater social stability. But if in their "first run" these novelty curtains could be read as a badge of conformity, of belonging to a solid middle class, in their recent reincarnation they have been transformed into tokens of iconoclasm and increasingly have had their images, patterns, and attitudes incorporated into contemporary fabrics and fashion.

To be sure, collectors of vintage barkcloth share the thrill of convention-bashing which lies at the core of much of Americans' fascination with their abundant kitsch culture. But novelty drapes hold a sharper ironic crease: embracing contradictions, they are at once elegant and gauche, sophisticated and homey. In one graceful sweep they mock nostalgia and celebrate it. That is why their rich inventory of patterns has migrated from the drapes and upholstery of knotty-pine rec rooms to the high-style fabrics produced by Full Swing Textiles and to the neckties, shirts, and scarves manufactured by such designers as Nicole Miller and Format. No matter how humdrum or hokey they may seem in retrospect, fabrics ranging from 1930s florals to the 1950s atomic-modern designs that now adorn the living rooms of Cyndi Lauper, Bruce Willis, Barbra Streisand, Bette Midler, Woody Allen, Christie Brinkley, Anjelica Huston, and Madonna have been steadily percolating into private collections, prop rooms of major movie studios, and archives of such

institutions as the Cooper-Hewitt Museum. With patterns inspired by Tinkertoys, roadside souvenirs, tropical gardens, and intergalactic space, these textiles evoke the quietude of an America buoyed by postwar optimisim, the marital bliss of Ozzie and Harriet, and sleek-finned automobiles. Most private collectors of midcentury fabrics tend to acquire an assortment of styles—ranging in sensibilities from the flamboyant, Hollywood neo-Baroque floral patterns of the 1930s, to the abstract grids of the 1950s—and showcase them as pillows or accent upholstery for rattan furniture.

Generations of Americans have grown up with these curtains, so it is no surprise that the entertainment industry has been buying them up as props in fantasy re-creations of the past. Walt Disney Studios has been using them as backdrops for window displays and jewelry stores at their theme parks. These textiles have become indispensable for many filmmakers, who have purchased large quantities of the more unusual vintage fabrics and used them for sofas and curtains in such films as *Women on the Verge of a Nervous Breakdown, Drugstore Cowboy, The Mambo Kings, A River Runs Through It, Mr. and Mrs. Bridge,* and *Come See the Paradise.* Not surprisingly, perhaps, the riotous colors, gilt threads, and cubist shapes that characterize curtains of this period have also captured the imagination of designers and architects. And the demand, especially for wacky geometrics and cowboy figural designs, has grown at a staggering rate.

The majority of fabrics featured in this book reside in the archives of John Gramstad, a Portland, Oregon, collector of midcentury textiles, and Michele Mancini, a Newport, Rhode Island, purveyor of vintage fabrics and designer of contemporary textiles based on designs from this period. These collectors have specialized in curtain fabrics from the 1930s through the 1950s, which include exotic geometrics manufactured by Saison Happily Married Fabrics, florals by Potomac, and satin damask by Leana Mills, considered to be among the most desirable midcentury textiles. Although the most treasured pieces in both

collections include virginal yards of barkcloth still coiled in their original bolts, Mancini and Gramstad are always on the prowl for that undiscovered remnant at an estate sale, flea market, or thrift shop, where recent excursions have yielded curtain panels bearing an abstract design by Salvador Dalí.

A superior sleuthing instinct is crucial for collectors of of midcentury fabrics. Because the ice-blooded modernists of the 1960s prescribed naked windows for residential architecture, barkcloth curtains came down with just about everything else of the period. As might be expected, the majority of panels were quietly discarded on the trash heap of history. After a decade of rekindled interest in these textiles, it has become almost impossible to keep up with the demand of designers, architects, and collectors for vintage material. Described by Gramstad as "part picture-postcard, part Hawaiian shirt" in their visual impact, midcentury novelty fabrics are now favored for use as upholstery fabric for Heywood Wakefield dining room sets, Vladimir Kagan sofas, and rattan furniture. The increasing popularity of these fabrics has turned Mancini's once offbeat vintage shop, Full Swing Textile Collection in Newport, Rhode Island, into an internationally recognized outpost both for vintage fabrics and for meticulously and ingeniously reconstructed barkcloth reproductions manufactured on special looms.

Although curtains and related textiles have been enjoying a renaissance, there are skeptics who consider many of these fabrics downright ugly. "Collecting anything is a tricky, very personal, and sometimes controversial endeavor," says Gramstad. Indeed, it is. But when it comes to midcentury fabrics for the home and garden, Gramstad is quick to point out, "If it weren't for these bolts of barkcloth, it would have been curtains for me long ago."

Gideon Bosker

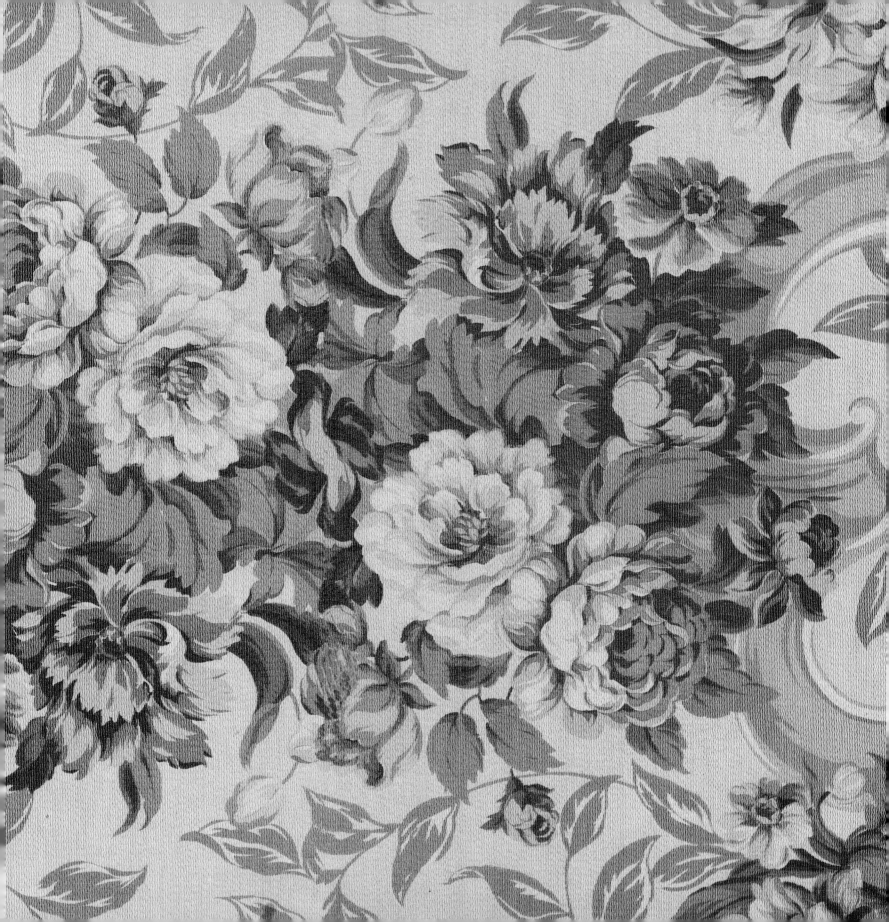

Flower Power

In domestic textiles, floral prints have held an undisputed monopoly since the turn of the century. During the 1920s and well into the 1950s, flower prints dominated living room and dining room decor in homes throughout the country. Showing a staggering diversity of subjects, floral textiles of the era usually reflected current gardening fads. Camellias, lilacs, roses, and ferns—singly or in combination—were sometimes enlivened by the addition of a richly plumed bird.

It is interesting that at a time when America was perfecting the skyscraper—the modernist architectural form par excellence—the focus in interior design was fixed almost exclusively on antique furniture or reproductions of such period styles as American Colonial, Italian and Spanish Renaissance, Tudor, or the nineteenth century periods of England and France. Not surprisingly, textile design was still firmly entrenched in an aesthetic of flowers which had remained virtually unchanged throughout the preceding two hundred years.

Florals were the preferred fabrics for armchairs and couches, and were chosen to "go with" scrollwork chandeliers, knickknack cabinets, and gilt furnishings. Florals against dark backgrounds were all the rage in the early 1920s when lacquered and gilt furniture was in vogue.

In the early decades of the twentieth century it was unusual to find floral prints betraying the influence of the nineteenth century British Arts and Crafts movement or the sinuousities of Art Nouveau. Only in the treatment of intertwining stems or elongated leaves that drooped, curved, or swirled more hyperbolically than they do in nature could the impact of new design sensibilities be felt. In fact, American floral textiles showed a remarkable resistance to "modern" styles until well into the 1940s.

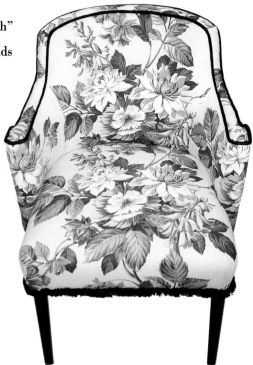

16 *The dramatic impact of this free-fall, vining inch plant is achieved with only three colors on pebblecloth.*

A Kandell floral design from the mid-1920s is rendered on rayon French faille. (right)

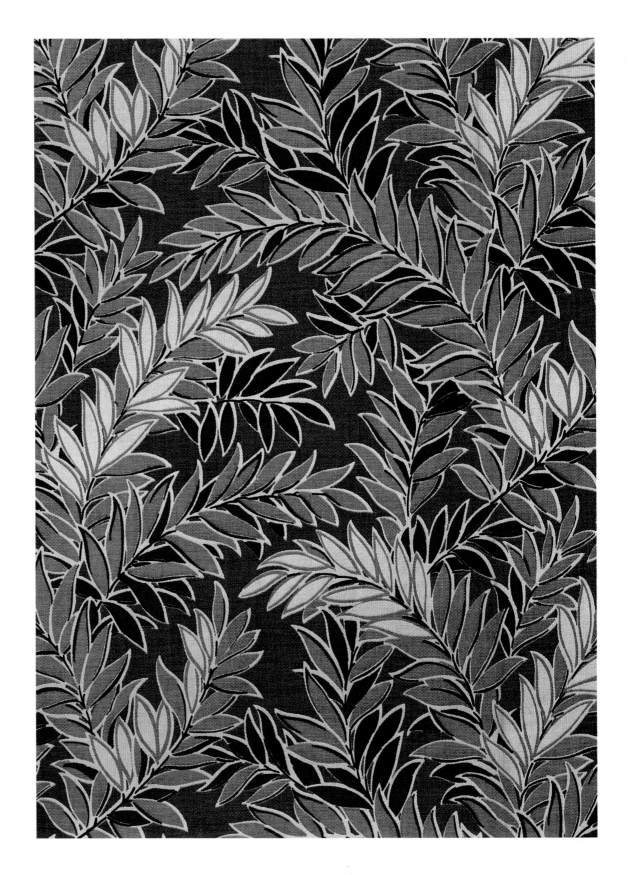

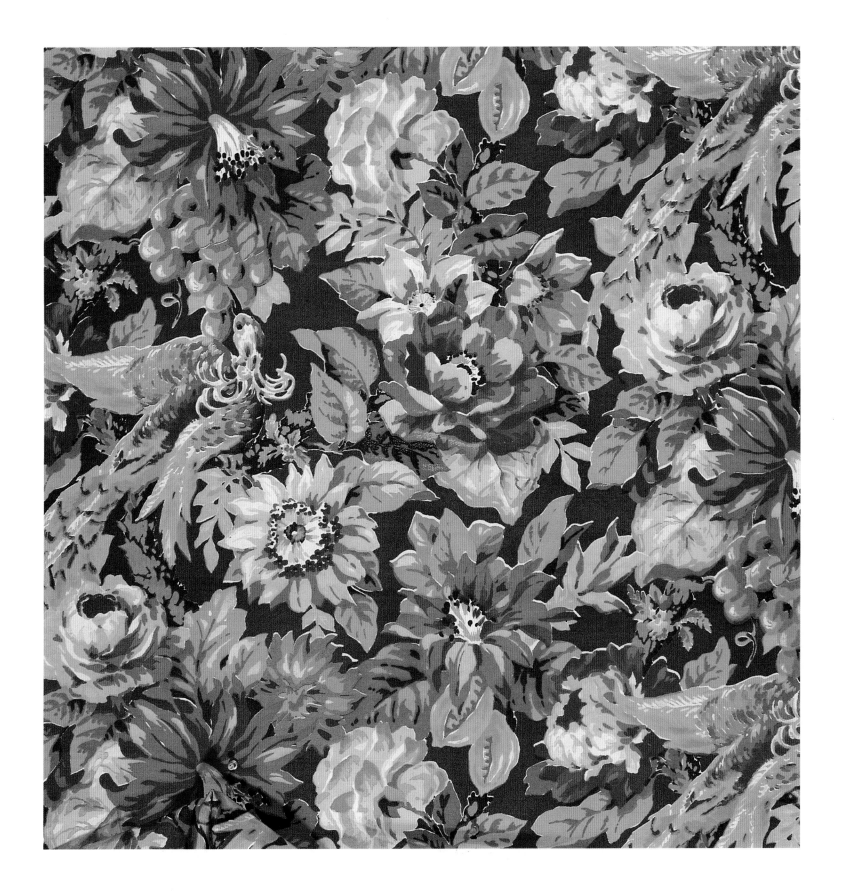

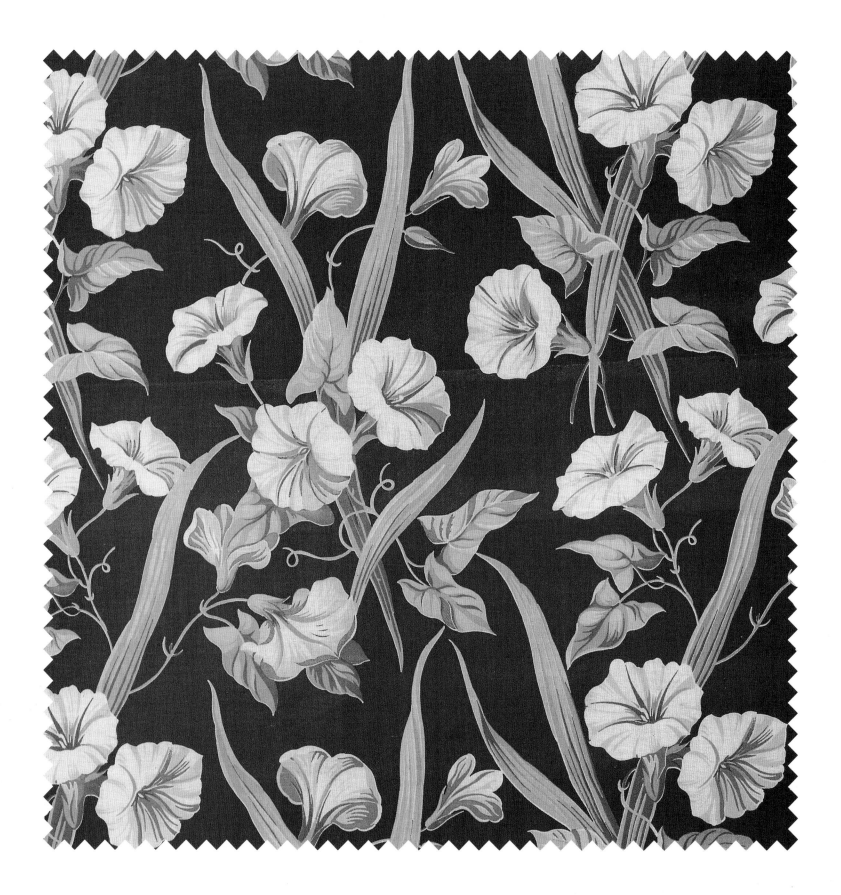

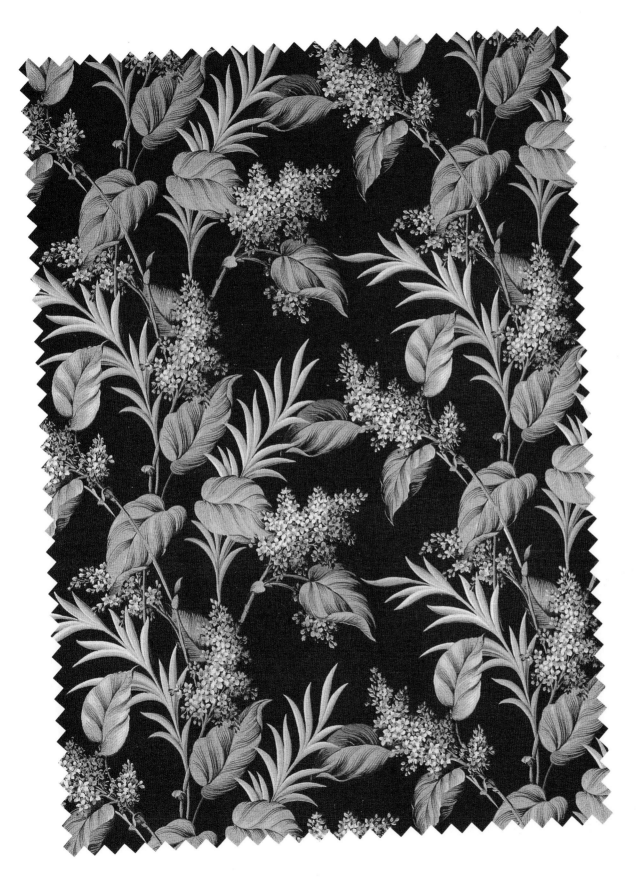

This barkcloth scatter pattern of lilacs against a deep burgundy ground dates from the mid-1930s.

White morning glories climb up a pattern of crisscrossing leaves that mimic trelliswork in this pima cotton broadcloth circa 1920. (left)

20 *P*ale camellias are scattered on an *unusually dark oxblood ground in this finely woven pima cotton circa 1920.*

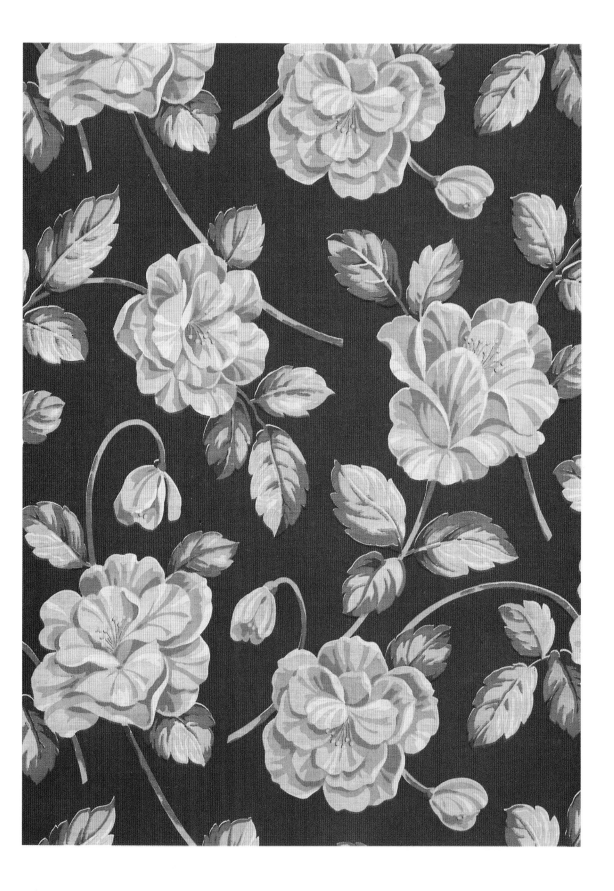

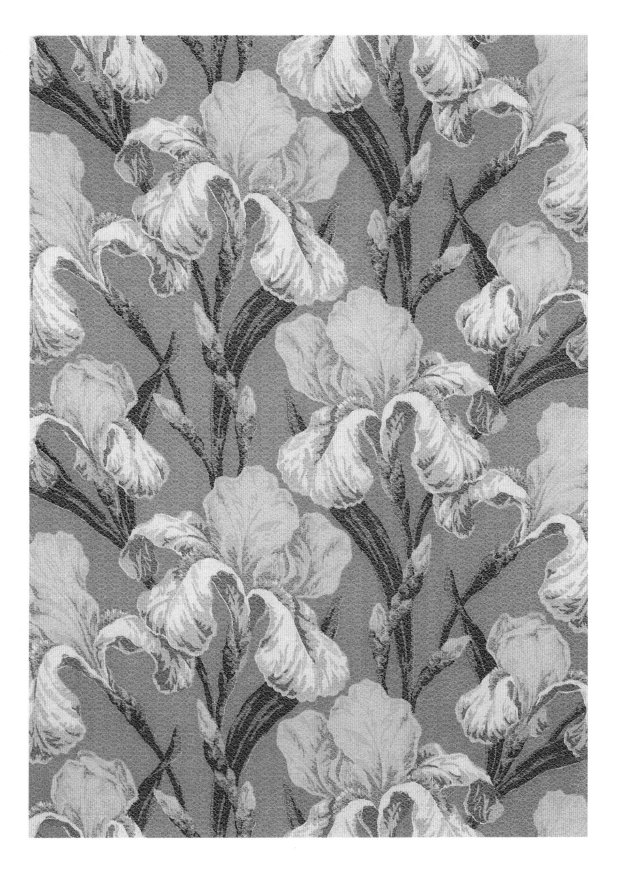

Interlacing white bearded irises are screened onto a diamond-weave wafflecloth from the mid-1930s.

21

The rhododendron is an unusual choice for this scatter floral in bark-cloth dating from around 1941. (following pages)

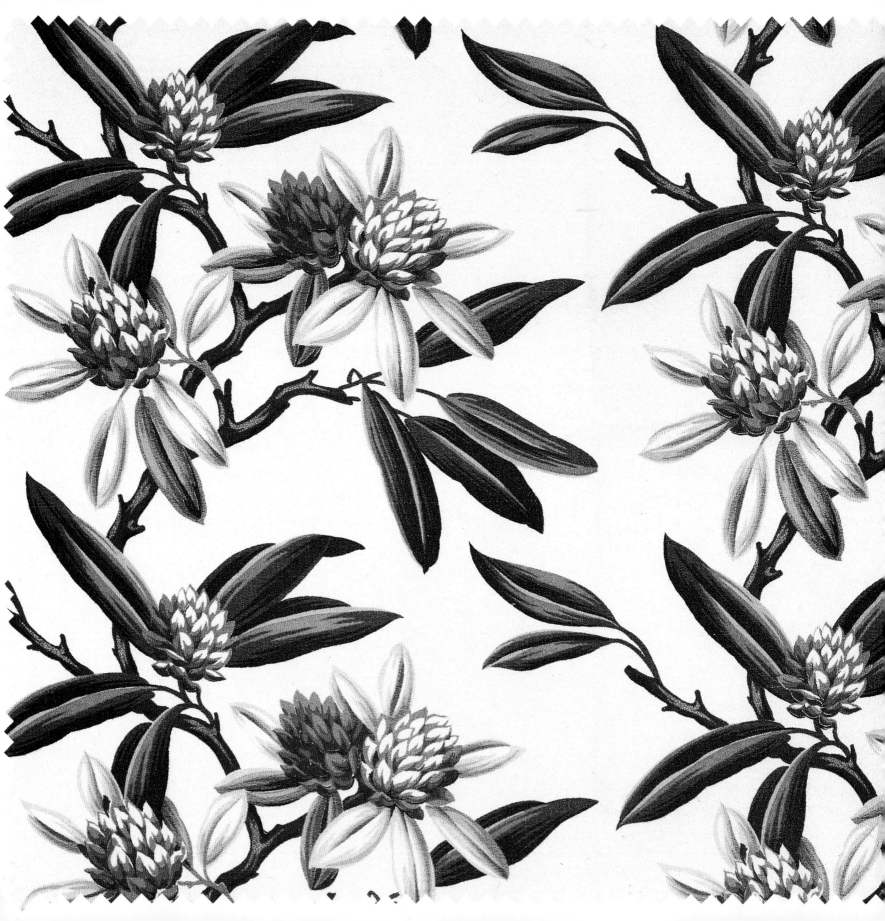

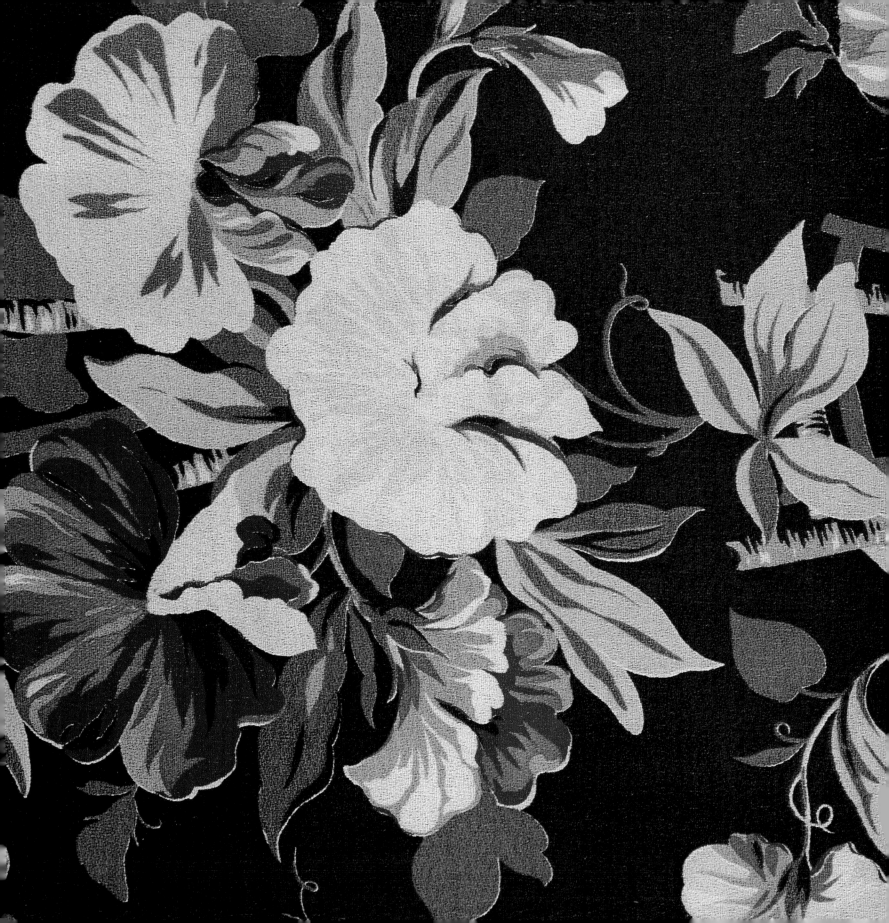

Cluster's Last Stand

The 1920s and 1930s in American textile design are unthinkable without reference to the ubiquitous floral cluster patterns. These groupings of the most diverse products of the American garden were arranged with great ingenuity and verve. Unabashedly anachronistic, they frequently embodied many of the motifs used by eighteenth century designers such as swags of flowers, lattices, ferns, and the occasional bird. Although enjoying limited prestige in high-design circles, themes based on the floral cluster were immensely appealing to mainstream society.

Even though the 1925 Paris Exposition of Decorative Arts had fundamentally shaken thinking about architectural and interior design, Americans for the most part remained loyal to traditional curtain and upholstery treatments. What innovations did manage to creep in were mainly restricted to the introduction of novel printing techniques or new textile fibers. In the early 1920s, for example, the demand for rich metallic fabrics increased—especially those woven with silver—and artificial silk was frequently used as a basis for metal threads.

As the storm clouds of the Great Depression and later global conflict gathered on the horizon, the demand for the floral patterns of the eighteenth and nineteenth centuries held steady. Colorful, pleasing, and above all escapist, these textiles gratified a growing yen for soothing, insulated environments. Marking a retreat from urbanism, the machine, jazz, and political uncertainty, the flower-bedecked fabrics fed a persistent nostalgia for the bucolic simplicities of country living; the charm of the garden, the peace of growing things.

Home was to serve as a retreat, and no fabric could render it serene with more flair—and economy—than the gentle floral print. Depending on the flower species, the density of the design, and the nuance of color, flower prints could serve a multiplicity of needs. The more formal designs were appropriate for living room drapes and couches, while the whimsical arrangements, particularly those projected against some semblance of a trellis, were suited for less formal areas and for garden furniture. While undoubtedly the workhorses of domestic textiles, the floral cluster prints performed their decorative function with grace and consummate charm.

26 *Strawberries, dahlias, foxgloves, and zinnias trail across this 1930s broadcloth.*

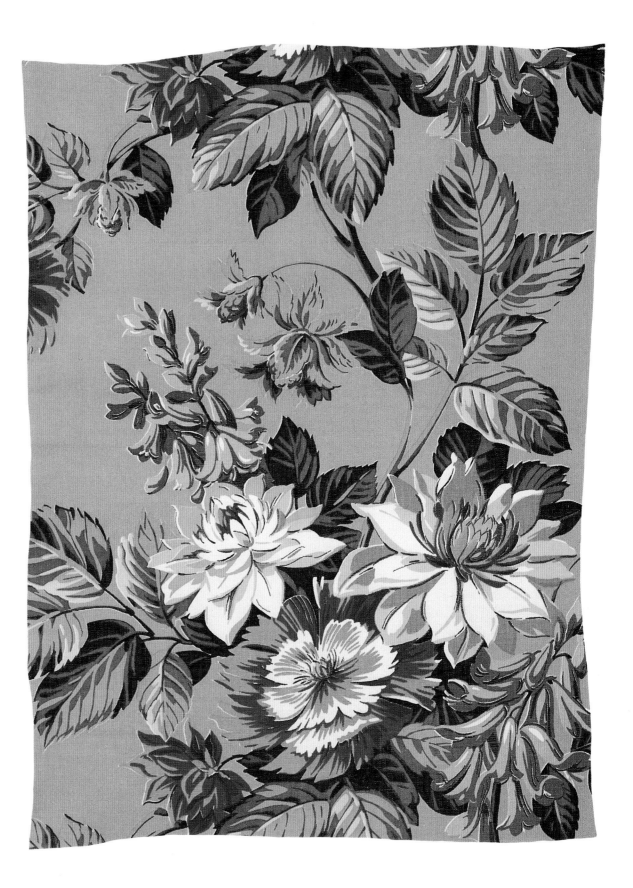

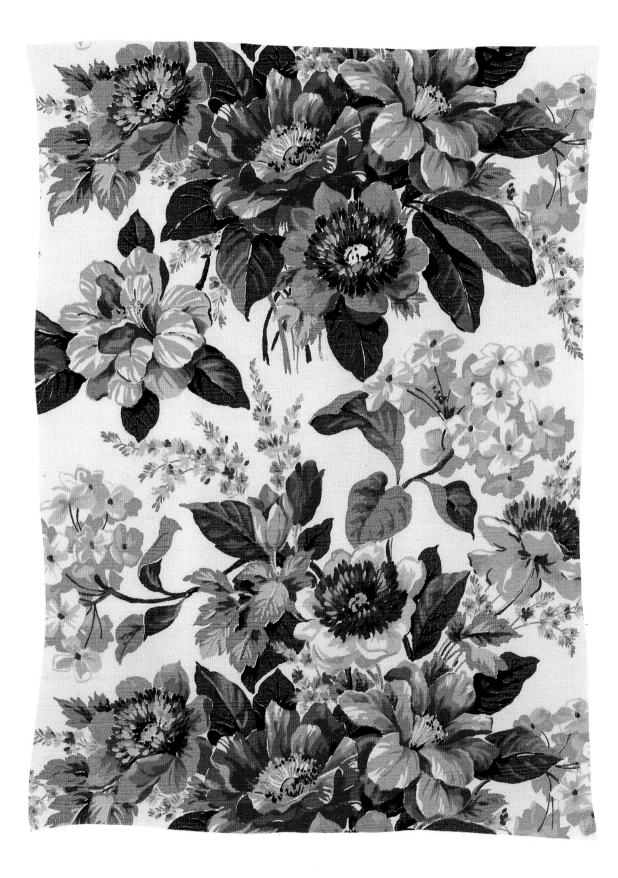

Standish Mills produced this circa 1934 birchbark-weave ground.

28 *The blowsy clusters of blown roses on this 1934 broadcloth create a grid pattern exclusively through the juncture of foliage.*

A strikingly monochromatic peony cluster floats on a slate-blue ground in this 1942 birchbark.

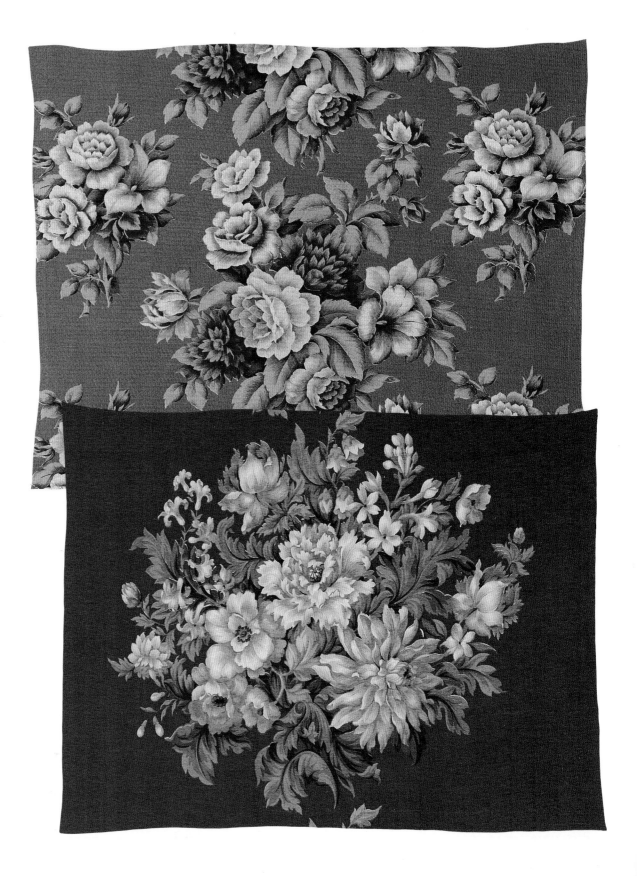

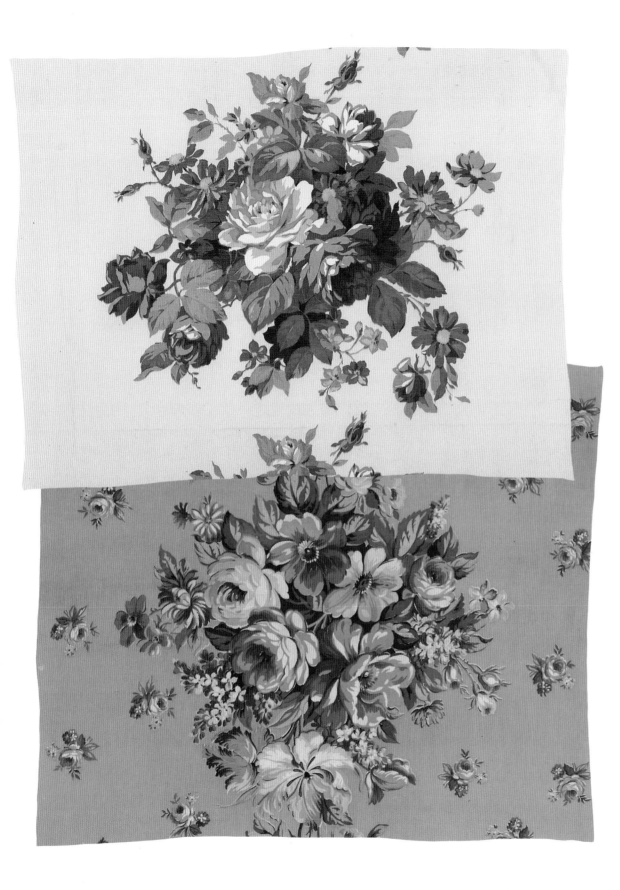

This circa 1934 twill-weave canvas presents a vertical ordering of isolated repeating motifs of garden blooms.

An overall design of small-scale patterns offers a graceful counterpoint to the tight knots of blooms. This canvas-weave cotton dates from the 1930s.

30 This 1934 diamond-weave waffle-cloth features an unusual collection of flowers in symmetrical, half-drop arrangements.

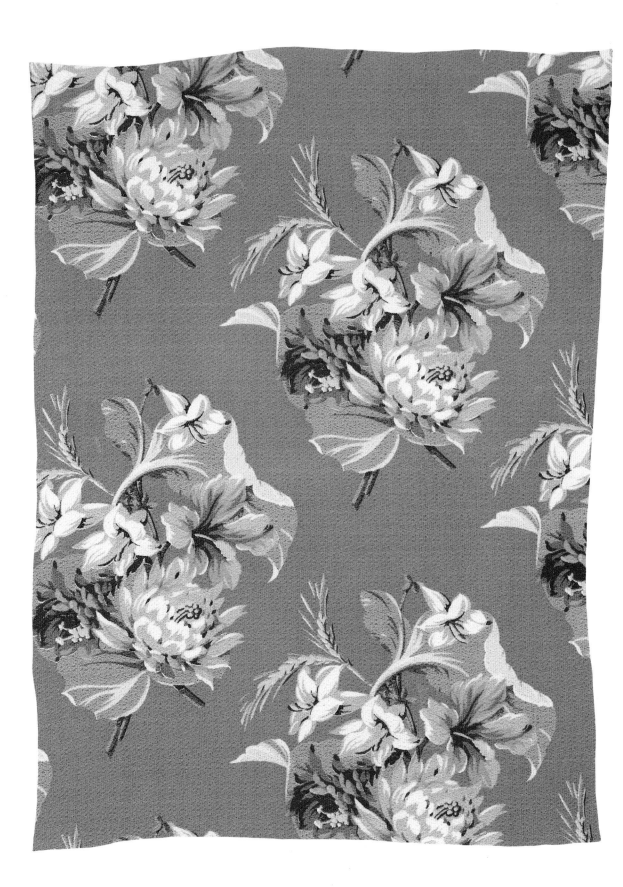

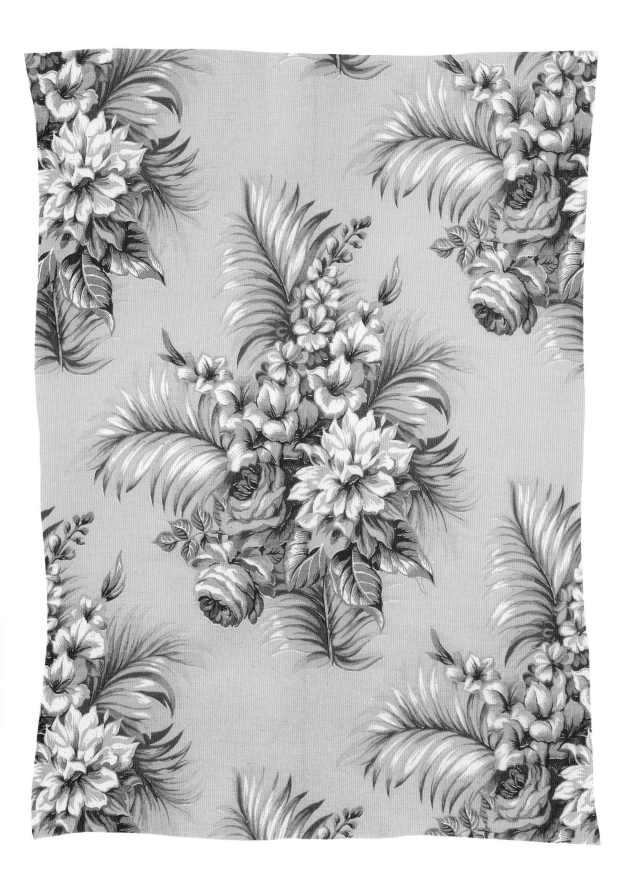

"Palm Bouquet," a fine, linen print from the mid-1930s, features an outstanding "apricot bisque" ground. The white highlighting contributes to the theatrical character of this floral.

In this linen-weave cotton from the early 1930s, the tuberose appears against a subtly rendered grid pattern of intertwining stems. The print was available in ground colors of blue, yellow, rose, and sage. (following pages)

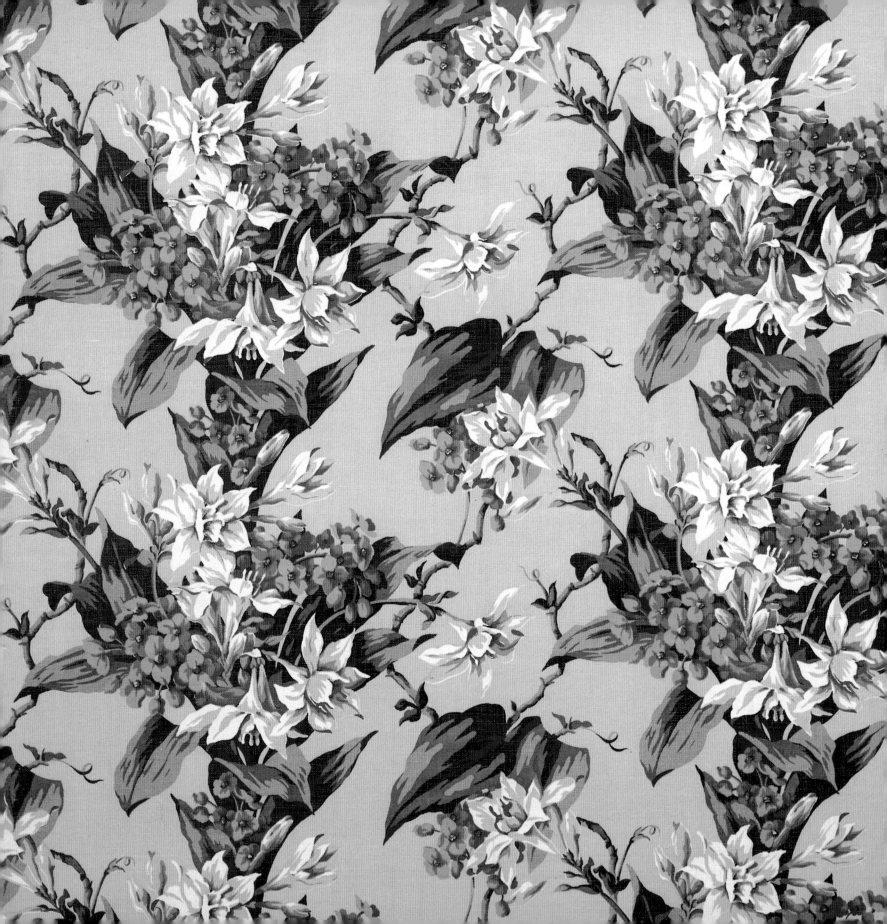

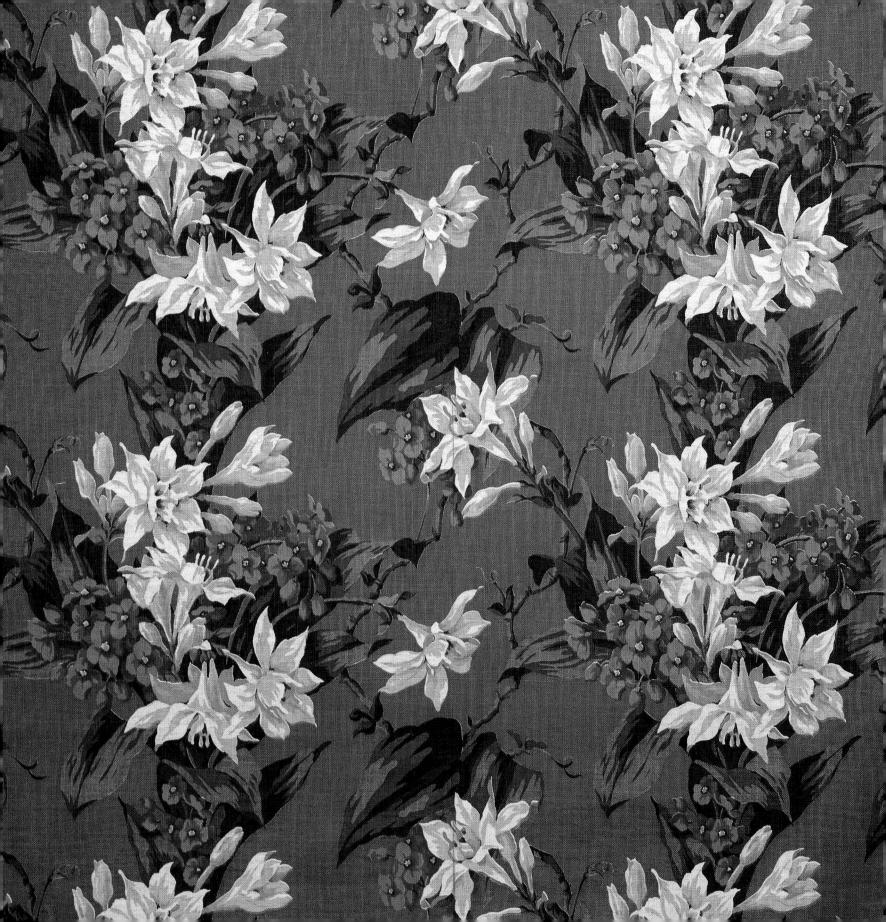

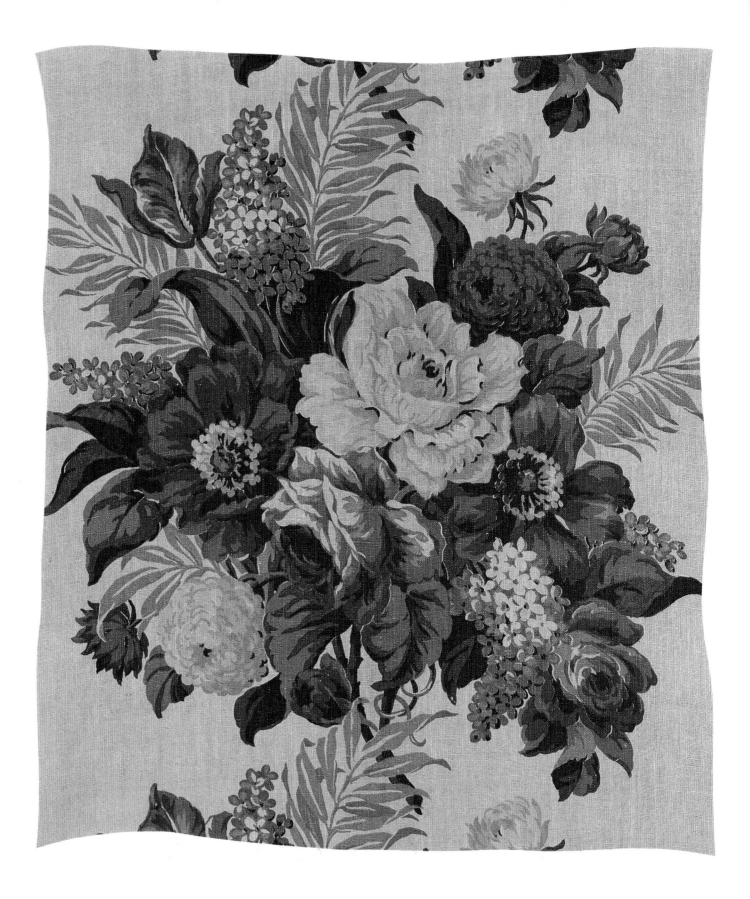

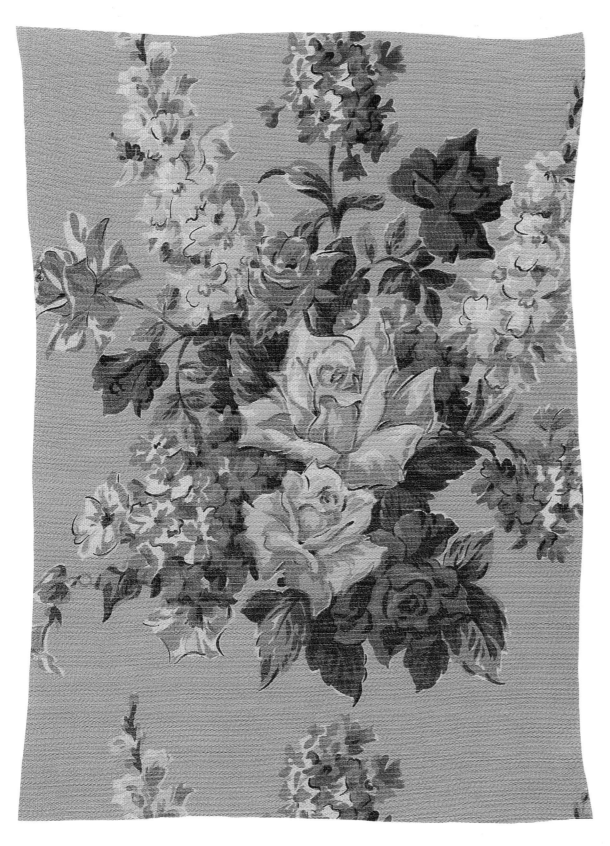

"Orleans," a Puritan Vat Print from
around 1930, offers an example of
outstanding resolution of pattern on
a silvery bengaline-weave ground.
(right)

The ecru background of this lush
botanical print on linen, dating from
the late 1920s, recalls the treatment
of British chintzes from the turn of
the century. (left)

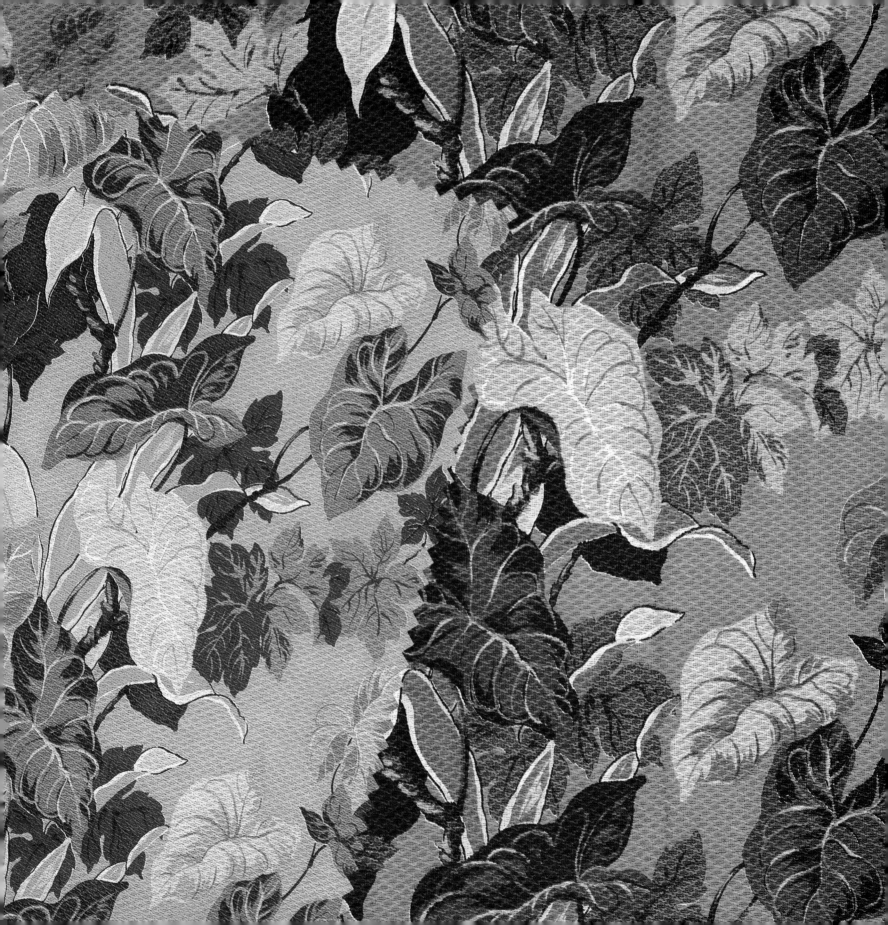

The vogue for all things tropical sailed into decorative textiles in the 1930s, right on the heels of Art Deco, luxury ocean liners, and America's infatuation with motion, speed, and travel. A promiscuously eclectic style, Art Deco drew on the fine and decorative arts of diverse cultures and periods, bringing into the mainstream many previously marginal or even neglected themes in interior ornamentation.

Exaggerated and profuse, the decorative imagery of the tropics held a particular appeal during the grim years of the Great Depression. Incubated in designs for interior appointments of ocean liners such as the fabulous cruise ship Normandie, in elegant resorts throughout the Caribbean and Mediterranean, and in residential enclaves such as Miami's Deco District, the tropical iconography of fabrics was devised to reinforce the mood of fun, fantasy, and escape. Hollywood films of the era democratized the feelings of hedonistic delight in the frivolous fantasies of Fred Astaire and Ginger Rogers dancing past acres of drapes imprinted with tropical blooms. In fashion, resort wear was all the rage, and head scarves echoed the patterns of fleshy ginger blooms, lushly twining hibiscus, and tubular gladioli that proliferated on the walls of theme restaurants.

By the 1940s Carmen Miranda had taken over, leaving everywhere her trademark glitz and glitter. But while the "Brazilian Bombshell" infected fashion with such sartorial mannerisms as tutti-frutti jewelry, extravagant headgear, and the "strawberry-banana split" aesthetic, her impact on domestic fabrics was confined to kitchen textiles. The fruit-and-flower combinations were too outrageous and, frankly, too vulgar to appear with any effect in the living room or dining room drapes. Instead, the graceful rhythms of Tropical Deco prints remained the textiles of choice throughout the 1940s for complementing rattan furniture and giving bedrooms the romance of tropical getaways.

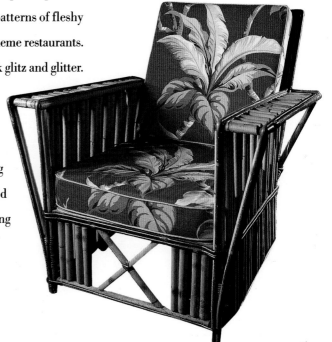

38 O*ne of the more intricate examples of the tropical flora genre, this bark-cloth from the late 1930s uses no fewer than nine colors for the foreground and three for the background, and combines two perspectives. It was also available in orange, black, and brown colorways.*

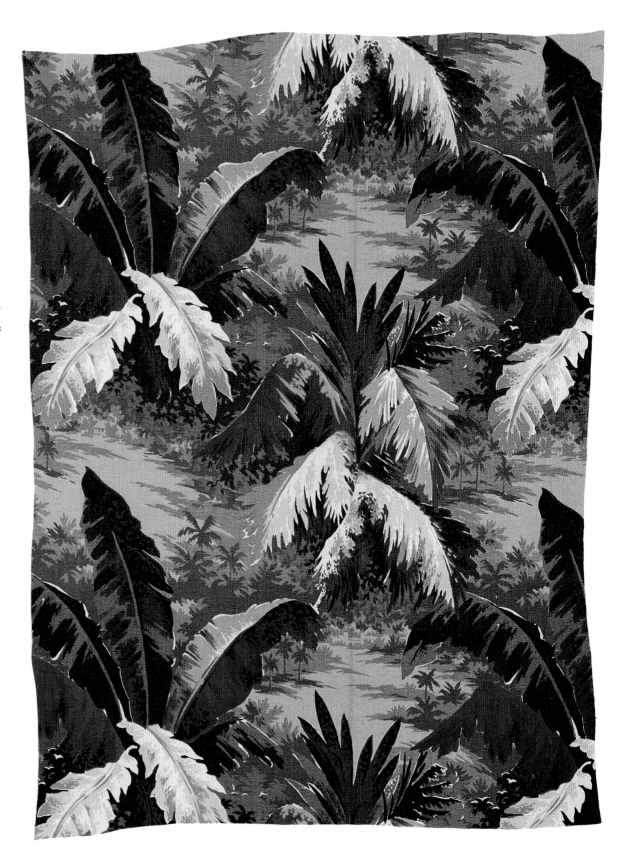

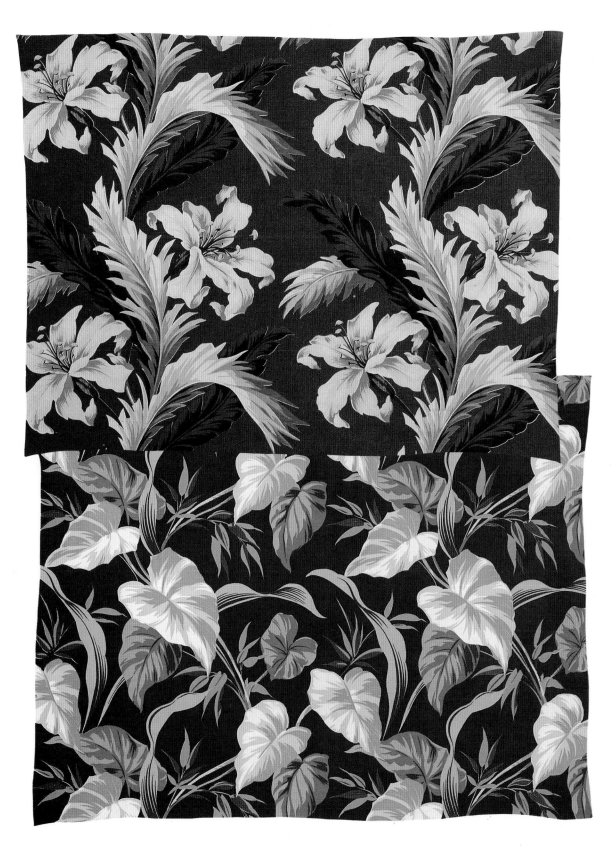

This lily-and-frond design, a canvas-weave cotton circa 1935, shows organic form in the service of geometry. With its sinuous, sigmoid curves, the pattern evokes the sensation of dynamic movement so important to the aesthetic of Streamline Moderne that dominated the decade.

Flowering ginger peeks from tropical foliage in this dramatic broadcloth from the late 1930s. The pattern was also produced on a gray ground.

40　*A nosegay of bleeding heart, dianthus, ivy, and hasta leaves dances across a pebblecloth from the late 1930s.*

This 1941 barkcloth displays undulating arrangements of magnolia blossoms.

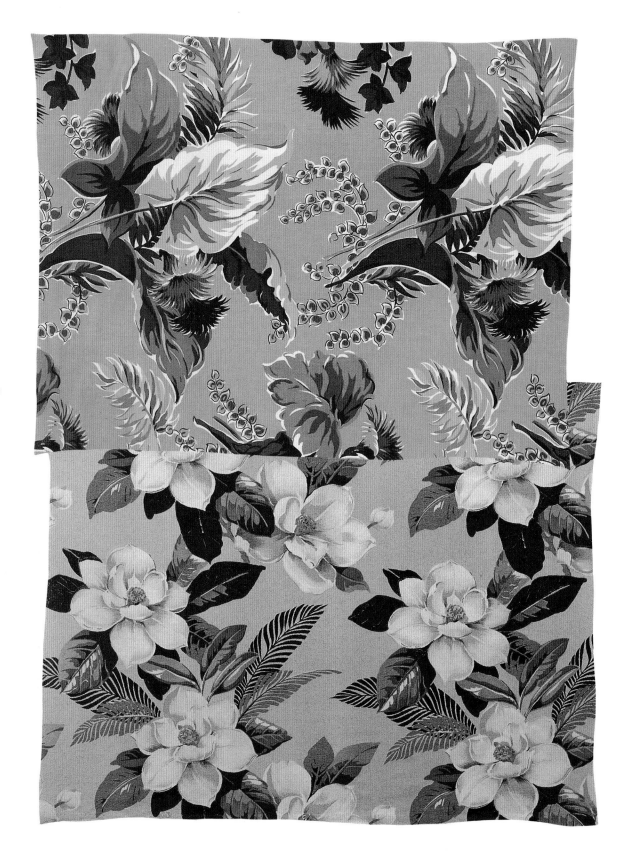

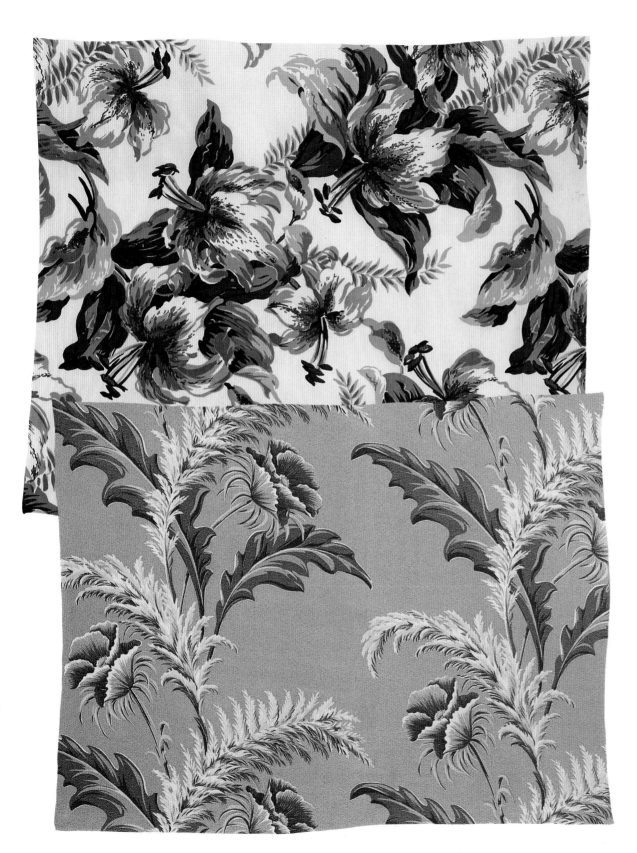

Clusters of stargazer lilies cascade
across the white, French, faille ground
of this 1948 Cohama Hand Print
titled "Lilies."

Oriental poppies interlace with
pampas grass in this 1938 print.

42 *Columnar arrangements of croton leaves give a muscular sense of structure to this barkcloth print from circa 1944.*

This pebblecloth Spectrum Original Vat Print of crême camellias dates from the mid-1920s.

The characteristic eighteenth century meandering stem motif is given a tropical twist with the addition of hibiscus blooms in this print from the late 1940s. By the mid-1950s, floral realism was on the decline. (right)

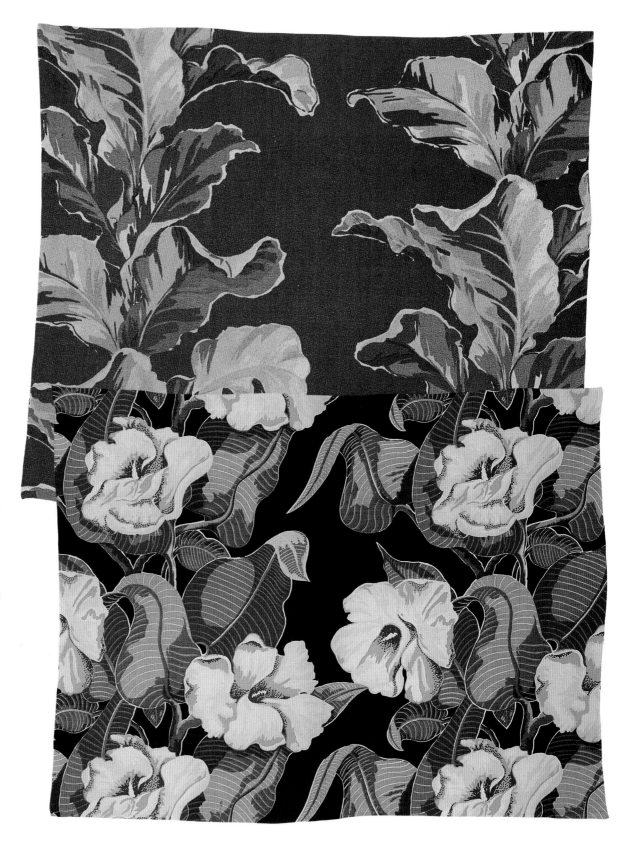

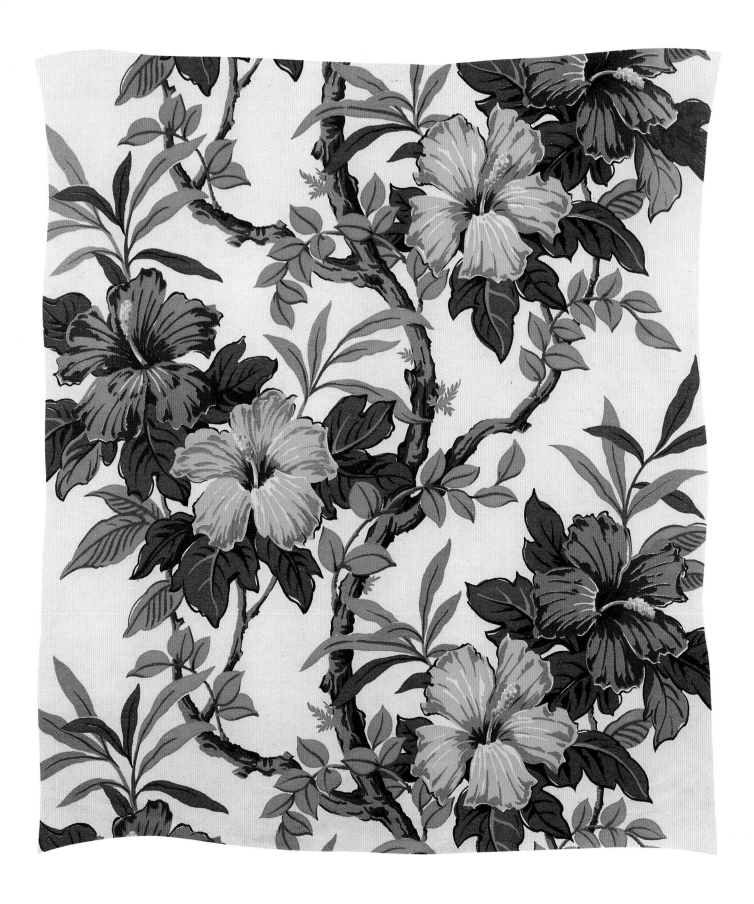

44 *The side-match pattern of white, Dutchman's breeches features an atypical plant choice for a period that favored tropicals or showier garden blooms. The pebblecloth dates from the mid-1930s. (left)*

During the Great Depression, figurative patterns gravitated toward natural, organic imagery. Lush, flowering plants, particularly the flora of the tropics, prevailed, as in this example of a barkcloth weave from 1932 which features palm fronds, ginger leaves, tuberose, and birds. (right)

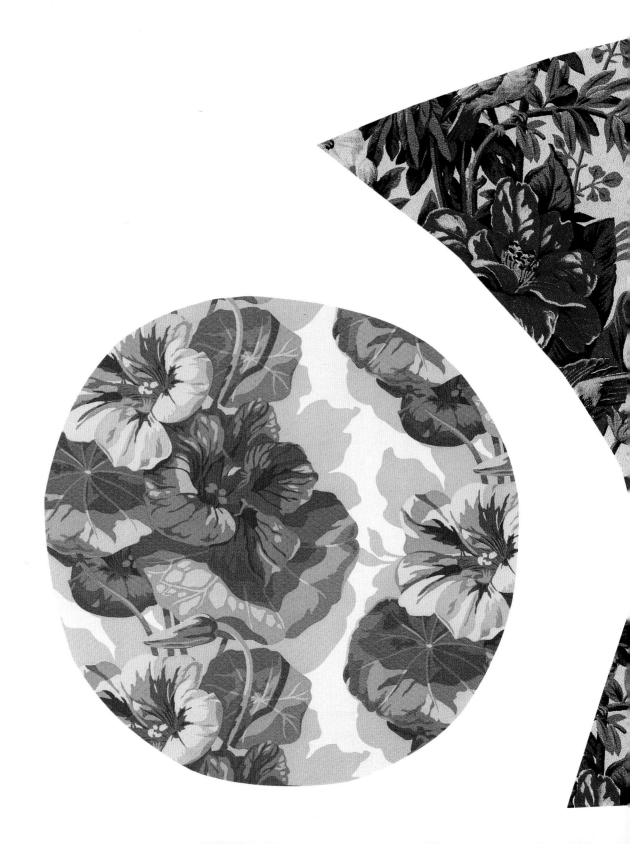

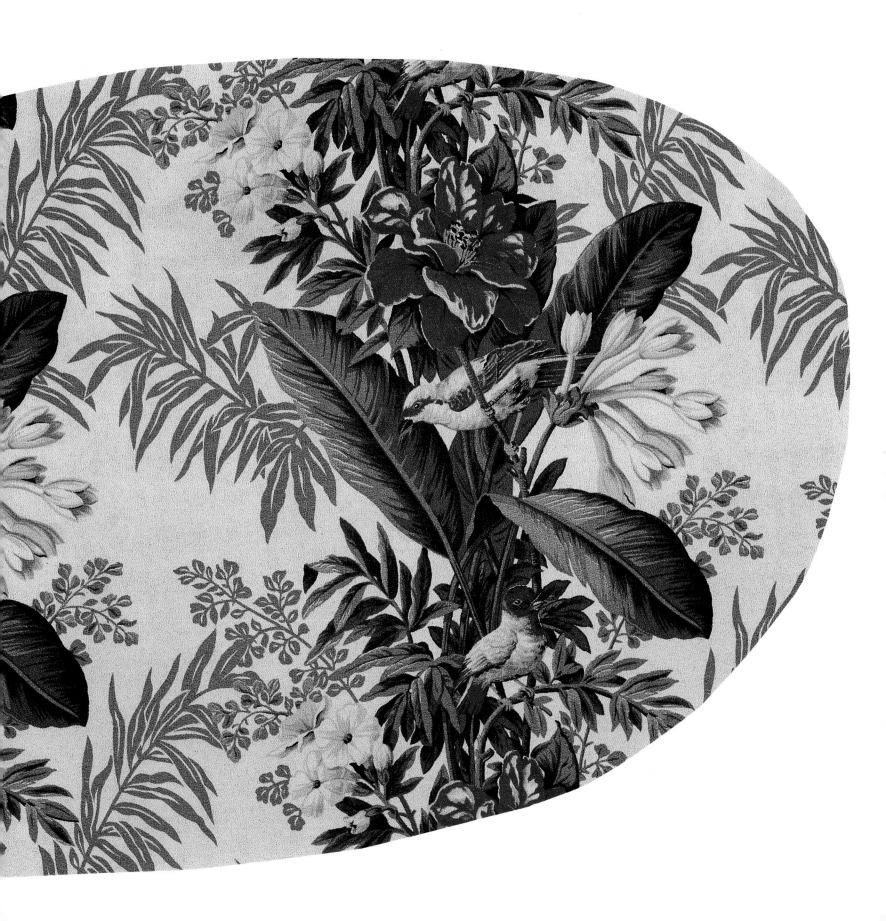

46 *Caladiums, hibiscus, and orchids are depicted with startling botanical accuracy. The slub-weave rayon and linen was produced in 1936 by Standish Mills. (left)*

This diamond-weave wafflecloth from the early 1930s offers a striking display of lily of the valley interspersed with pink stems and taupe leaves. (right)

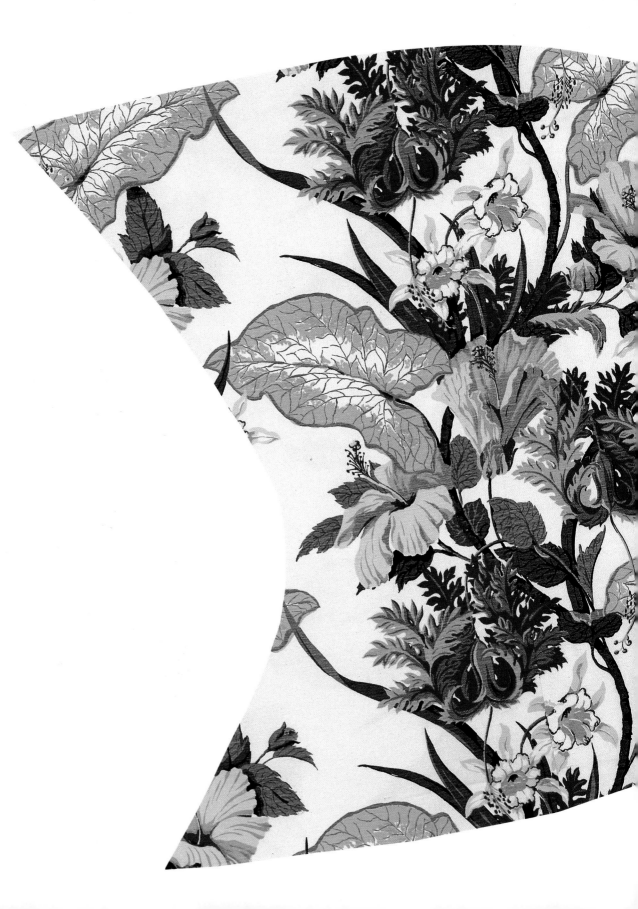

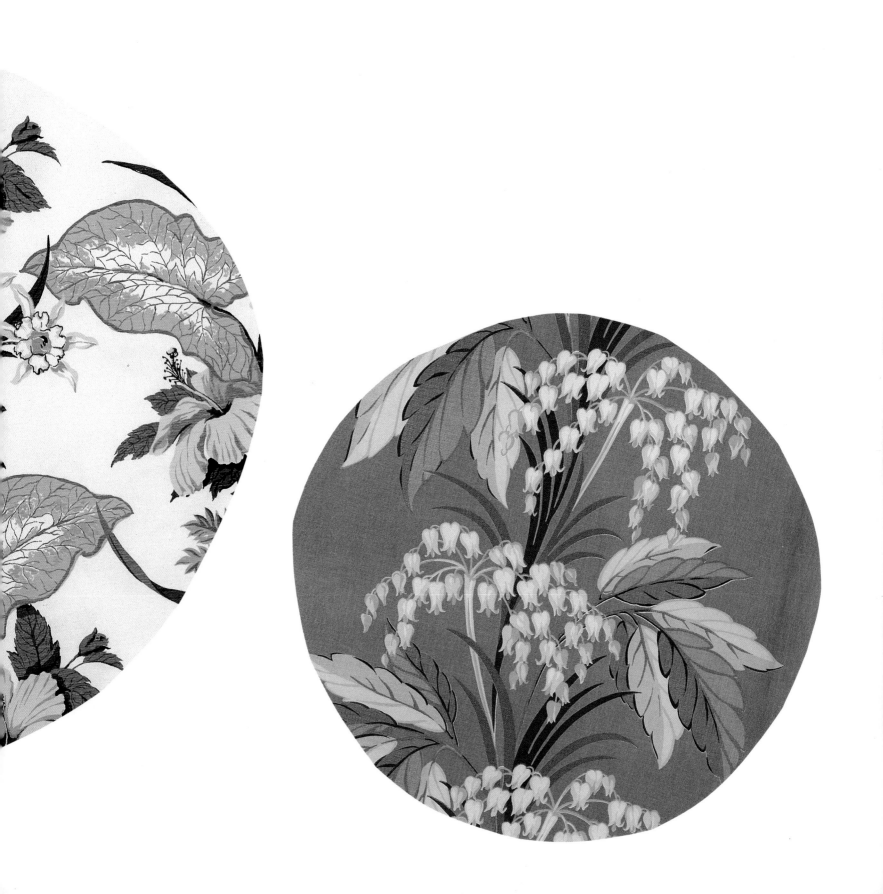

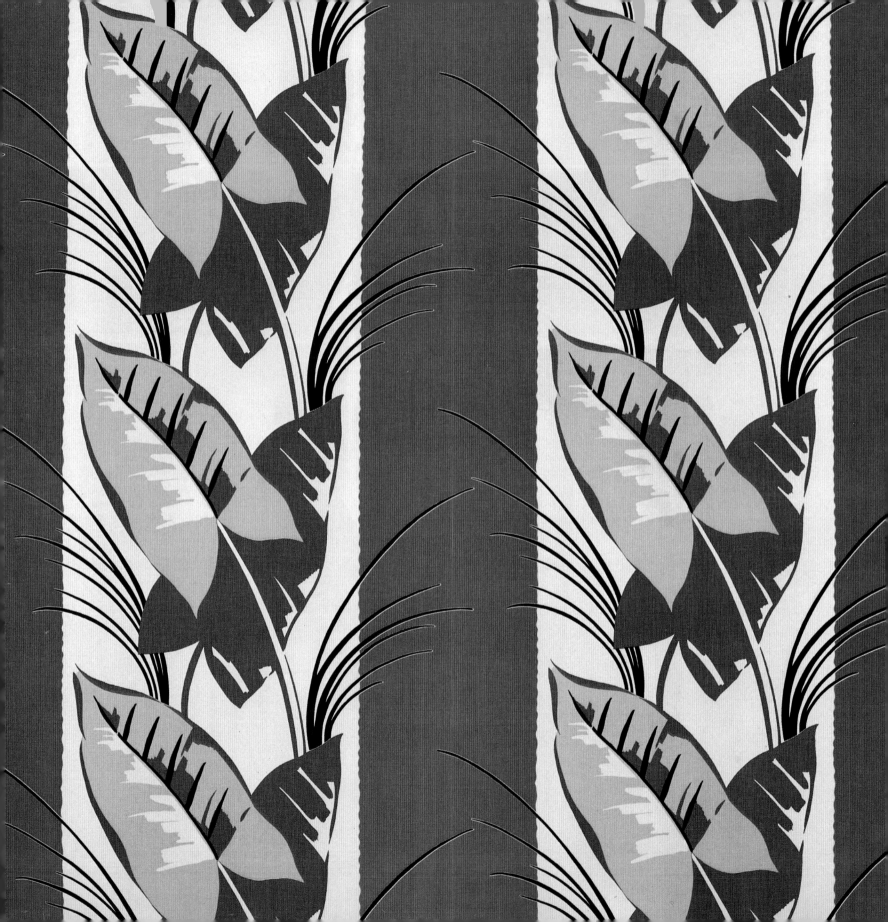

I f the floral cluster textiles were the workhorses of domestic fabrics, the vertical floral patterns were the thoroughbreds of fabrics designed for interiors of the 1930s and 1940s. Elegant, disciplined, and controlled, floral verticals straddled the zone between tradition and innovation. Here for the first time mainstream designers ventured into the new repertoire of patterns made available by the aesthetic of Art Deco. By so doing they succeeded in subordinating the spontaneous exuberance of plant forms to the mathematical order of vertical rhythms.

The vertical florals were particularly well adapted to the muted color schemes that came into vogue in the early 1940s when the war effort diverted many of the dyestuffs and natural fibers away from private enterprise. They also profited by the introduction of man-made yarns and by the process of rubberizing, which extended the range of application to garden furniture. When used in the home, the vertical florals were particularly effective in helping to relieve the austerity of 1930s apartments decorated in the newly emerging mode of the moderne.

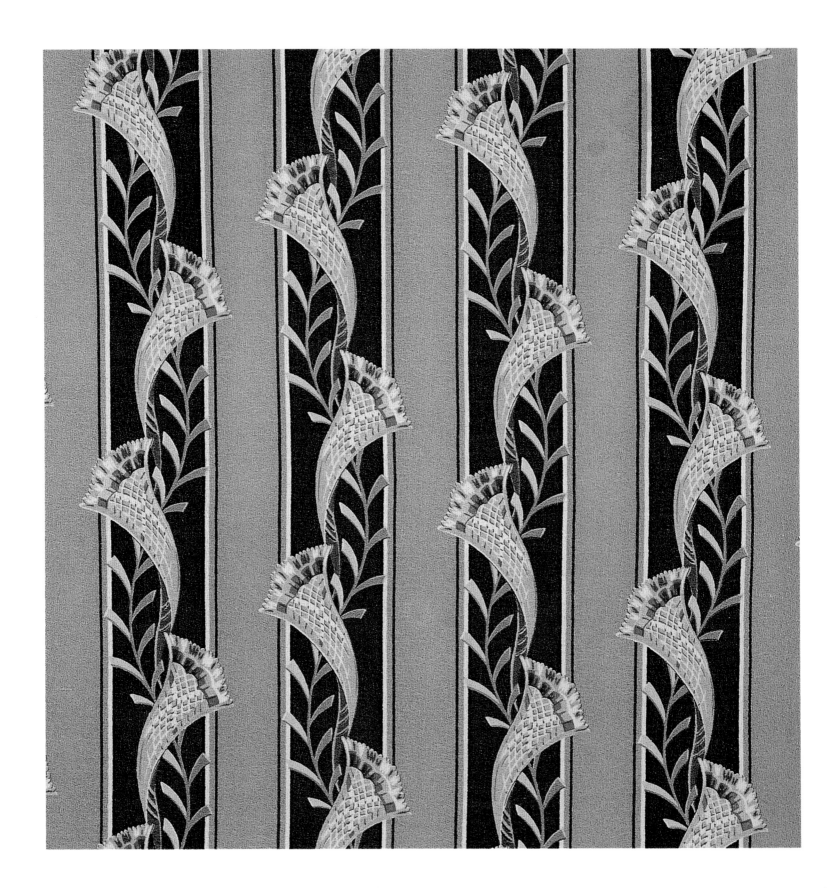

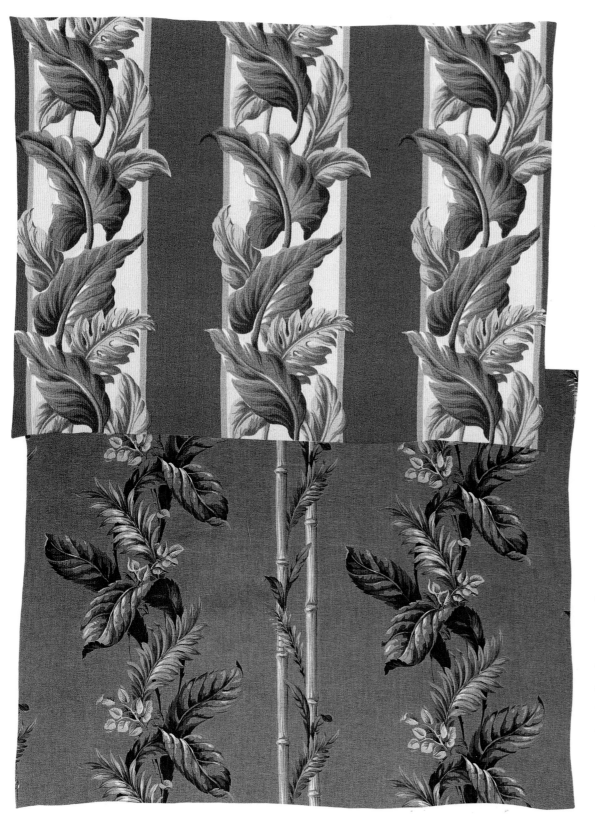

Textile designs of such uncommon quality and beauty as appear on this mid-1930s barkcloth were very affordable. *(top)*

The verticality of this 1940s print is relieved by the rhythm of dynamic diagonals sustained by the tropical foliage. In the sophistication of its execution, the pattern owes much to French prototypes. *(bottom)*

During the 1940s many American firms promoted a new concept of "the collection," introducing and advertising as a group coordinating fabrics in stripes or checks to match a floral print. These examples feature similar treatments of stripes and stylized florals. *(left)*

"Stafford Leaf" by Waverly was produced in two colorways on honeycomb-weave cotton. The stately hatband stripe with tendrils of flora was a characteristic motif from the late 1930s.

A pebblecoth floral-and-stripe design from the early 1930s reinterprets anemone-and-daisy clusters in a gray tonality. (right)

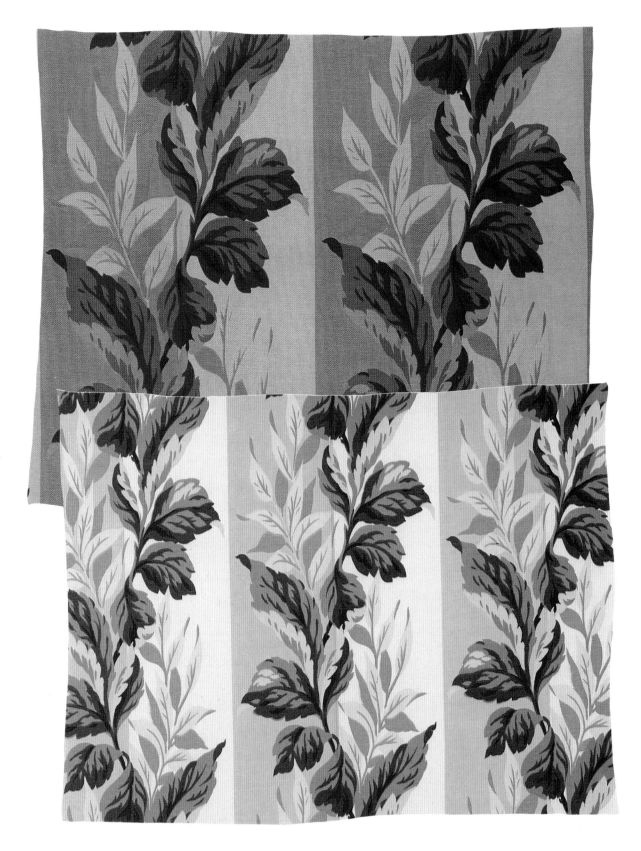

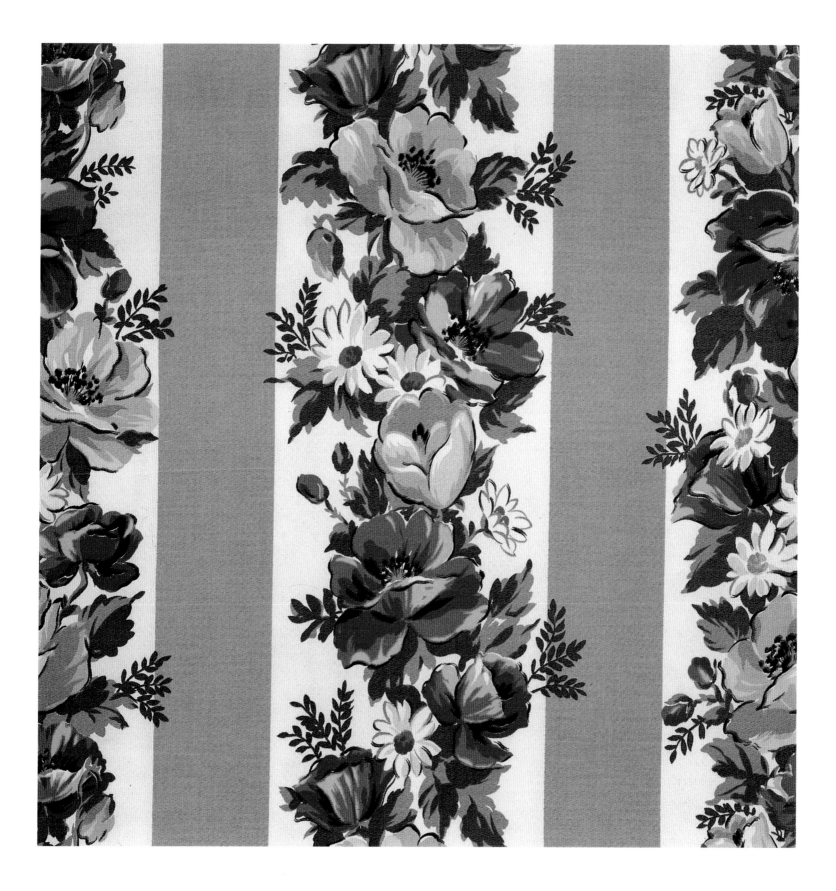

54 *The 1950s treatment of the hatband stripe and columnar leaf pattern is executed in signature colors of the late 1940s.*

Clockwise from top left
This lovely cottage floral with French curls completing the vertical half-drop dates from the 1930s.

"Futurama," produced by H. J. Fabrics in the 1950s, is an excellent example of birchbark weave. The textile would probably have been used in combination with Mexican figurals of the period.

A repeating, spiral rope motif climbs up the interlocking shell background of this extraordinary barkcloth from the 1950s.

Two variations of stripes frame a stylized running vine in this early 1930's pebblecloth.

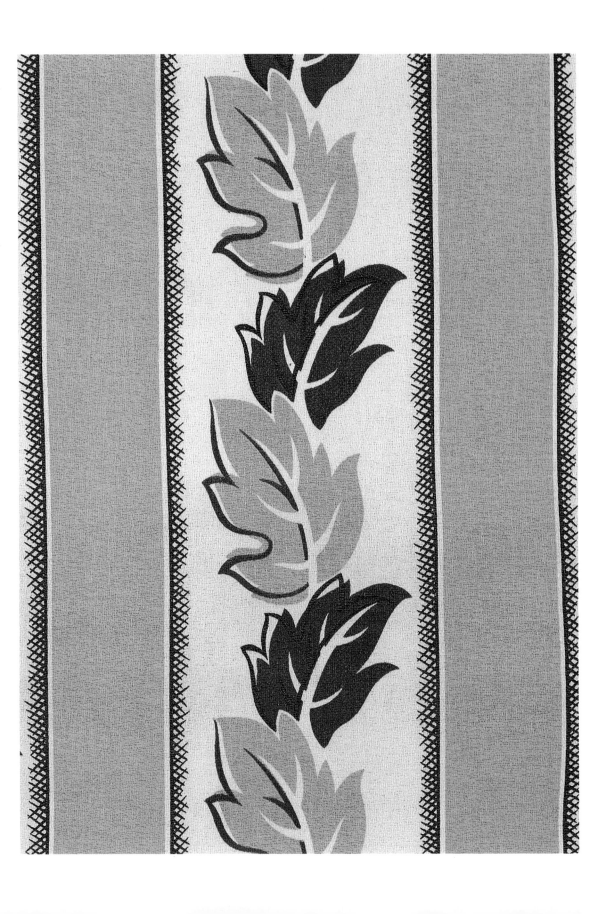

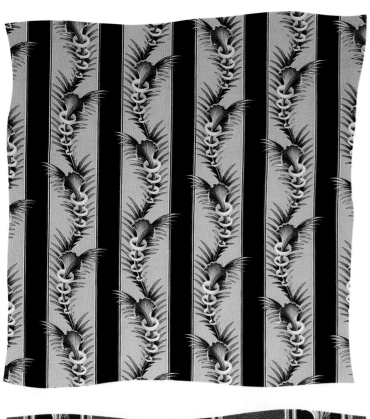
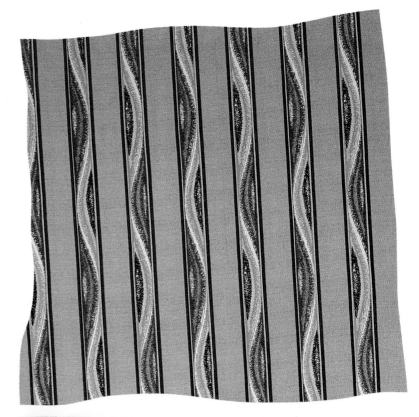
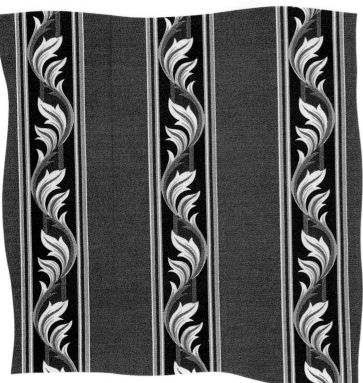
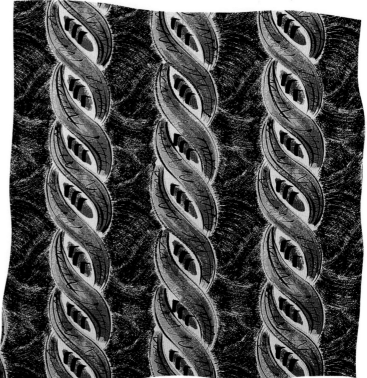

56 *The monochromatic, secondary background stripes that frame the daffodil column lend depth to the pattern of this early 1930s barkcloth.*

This polished cottage print from the 1920s shows the influence of the Wiener Werkstätte, the fin de siècle arts-and-crafts movement that flourished in Vienna, Austria. (right)

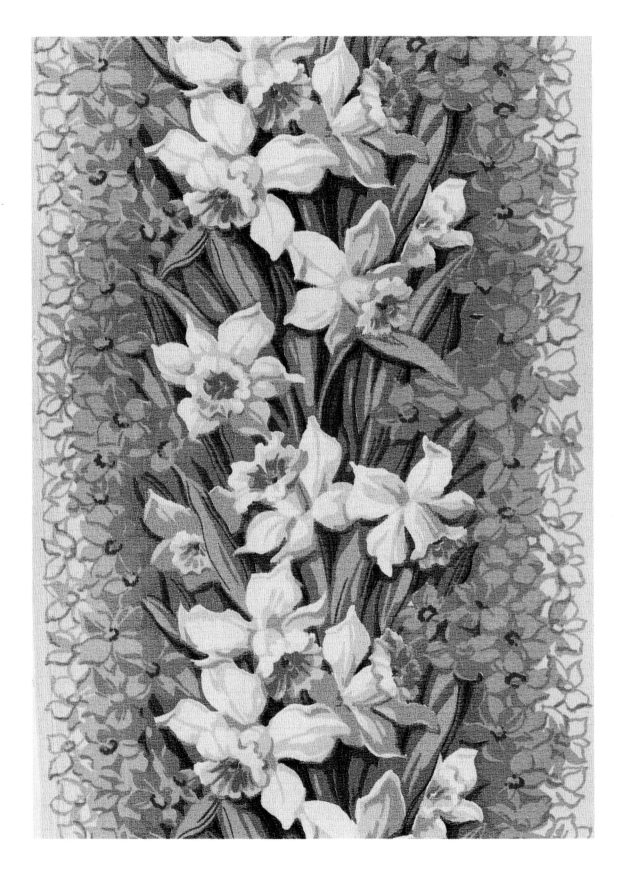

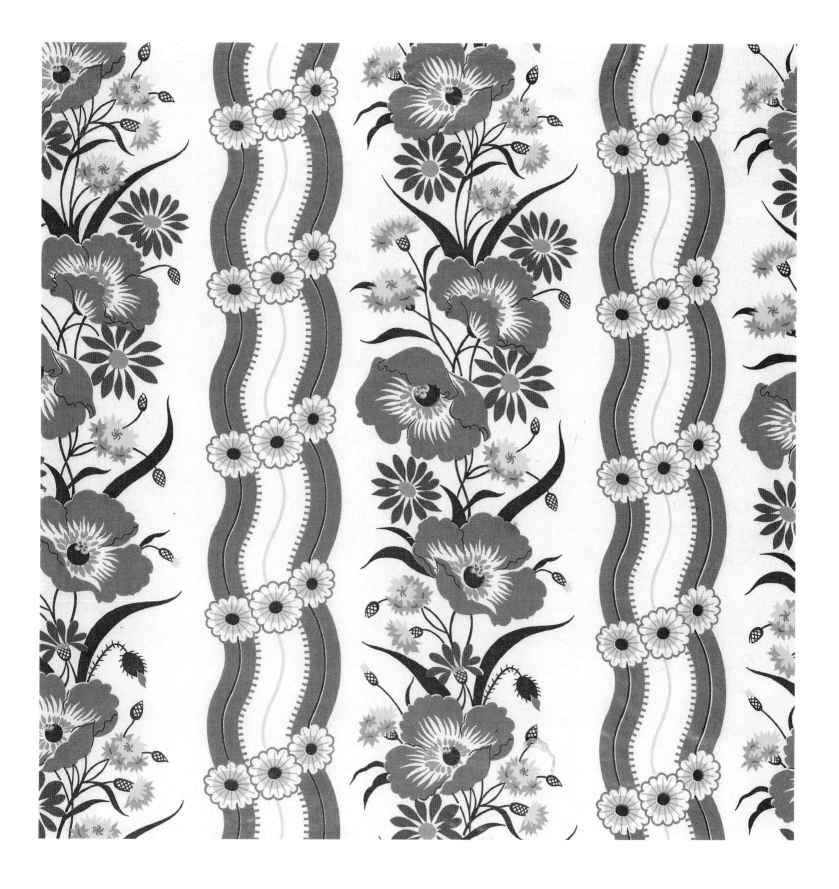

58 *Coordinating patterns were available for this textile titled "Brentwood Stripe," a Waverly Bonded Sister Print from the mid-1930s, which was produced in a distinctive bonded finish.*

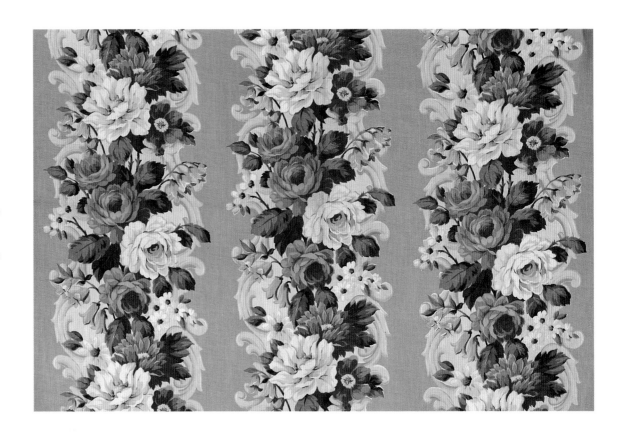

This wafflecloth from the late 1930s is an outstanding example of combining florals with geometrics. The white pussy-willow border provides a brilliant transition between the lush bouquet and the Art Deco-inspired chevron pattern of stripes.

The theatricality of this looping, lush floral from the late 1930s reveals the distinct Hollywood influence that made its mark on textile and wallpaper design of the period. (right)

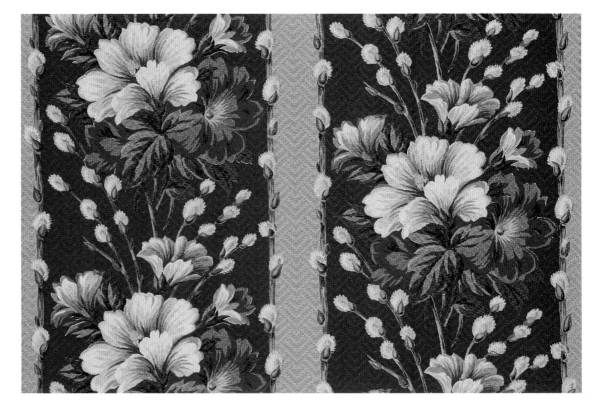

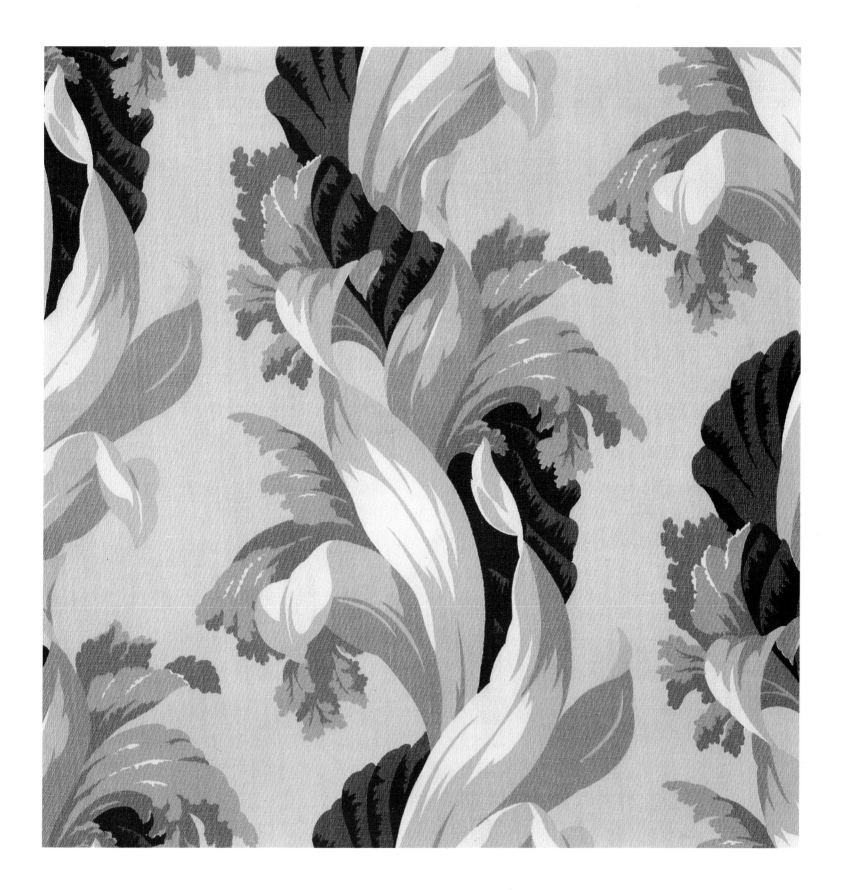

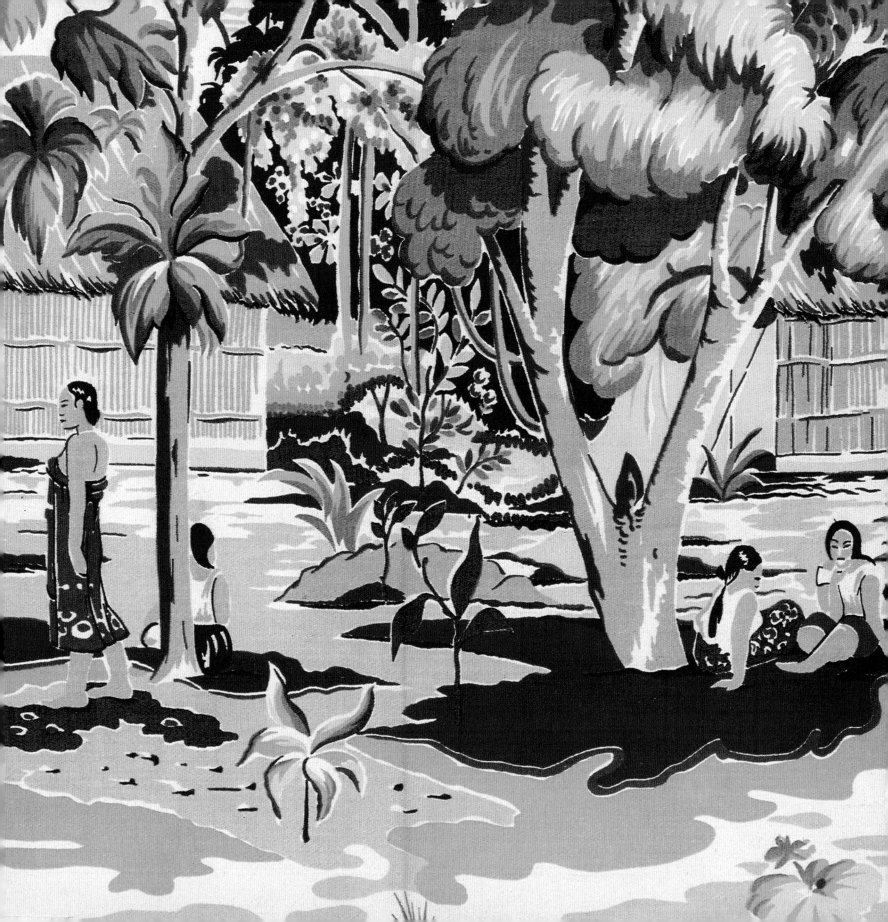

Witty, whimsical, or wacky, figurative textile designs have been an enduring and popular alternative to the more traditional floral and geometric prints. Typically their use has been restricted to the kitchen, the nursery, the adolescent's bedroom, and the family room, or den.

Ranging from the naive to the sophisticated, so-called representational or semi-representational patterns usually echo a dominant style in art, though often with the time lag of a decade. A characteristic painterly approach from the Works Progress Administration era may not surface on a textile design until the mid- to late 1940s, while late Victorian children's motifs retained their popularity well into the 1930s.

Whether screening the window over mom's sink or protecting the sheets in junior's bedroom, figurative fabrics celebrated collective fantasies, pop culture, and modish myths. Nautical motifs in cheerful red, white, and blue became especially popular in the mid-1930s, and remained so throughout the war years and far into the 1950s. In the immediate postwar period, figurative textiles fairly bristled with assorted Wild West motifs that tapped into a demobilized society's relief at being back home again. Folk traditions and folk art, such as Grandma Moses's naive scenes of pastoral pleasures, expressed the same impulse.

Walt Disney's *Dumbo* (1941) and a host of circus films through the mid-1950s fueled a mania for circus motifs, primarily in fabrics intended for children's rooms. Carousel horses, lion tamers, sword swallowers, leaping tigers, striped tents, red-nosed clowns, and performing elephants took over the nurseries of the child-centered 1950s, as they do again in the 1990s, when the boomer babies, now grown, strive to re-create their infancy for their own children.

The narrative dimension of children's nursery textiles has remained unaltered since the mid-1920s when illustrated books and comics began to furnish storybook characters and situations to parade across tiny beds. Short on prestige but long on fun, figurative textile designs pack a hefty dose of nostalgia.

62　*S*ymptomatic of a nation with an acute case of the travel bug, textiles such as this mid-1940s Kandell Print could have served as picture postcards. The pebblecloth fabric features scenes from the American Southwest in two colorways, or grounds.

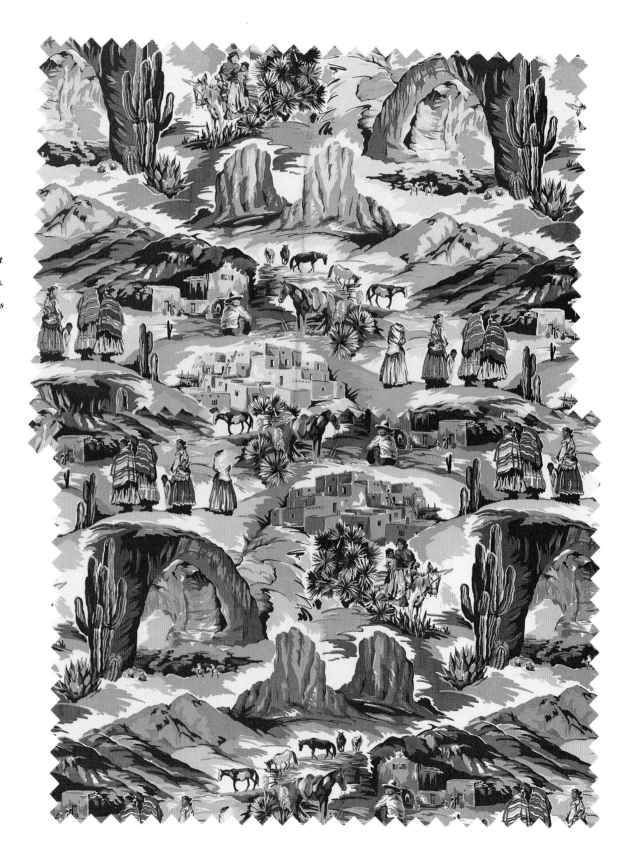

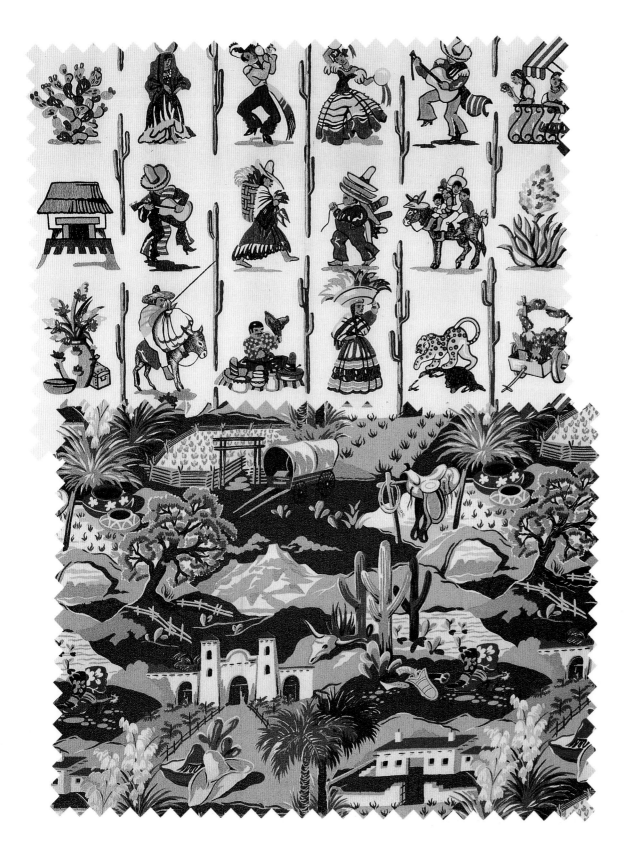

To the post-World War II imagination, Mexico represented the ideal "foreign" country: colorful, exotic, and most importantly, within easy driving distance. Mexican motifs were rarely rendered as finely as they are in this Signature Prints fabric titled "Carnaval" from the 1940s, which delineates rows of folkloric images with cactus stripes.

In an era of demographic displacements and instant suburbs, references to the colonization of the American West were abundant on the most diverse furnishings for the home. This superb example teems with icons of the Old West. Conestoga wagons, ten-gallon hats, saguaro cacti, and monuments of adobe architecture evoke an age of unbridled optimism and opportunity. This early 1950s birchbark is A Spectrum Original Vat Print.

64 *With its cheerful scattering of typical south-of-the-border scenes, this "Mexicali" pattern would have graced the windows of a 1940s kitchen, providing an engaging backdrop for the budgie in its cage.*

The repeating motif of hibiscus blooms sprouting from the base of a shaggy palm frames Caribbean views in this 1940s regional titled "Antigua." The sateen fabric was also printed with a black background.

This evocation of rural life in the American Midwest, dating from the late 1940s, borrows from the naive aesthetic of Grandma Moses, expressed in muted shades of patriotic colors.

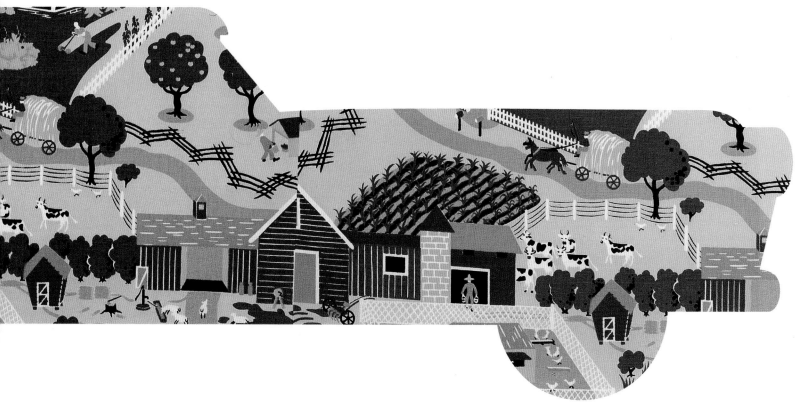

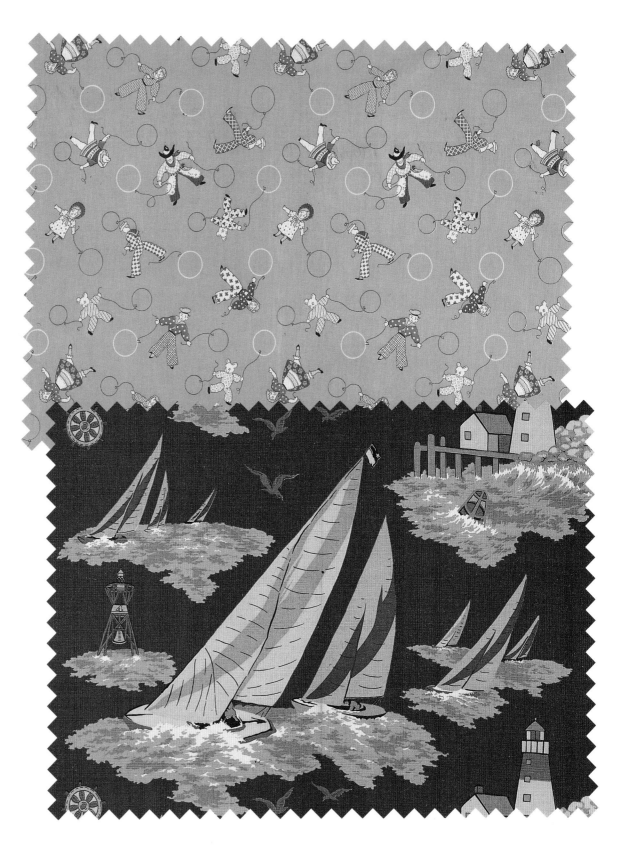

66 This glazed chintz proliferates with
 images of favorite fantasy friends:
 teddy bears and Raggedy Anns,
 cowboys and Indians, clowns and
 Mexicans.

 Sailing off the coast of Maine inspired
 this early 1950s birchbark weave.

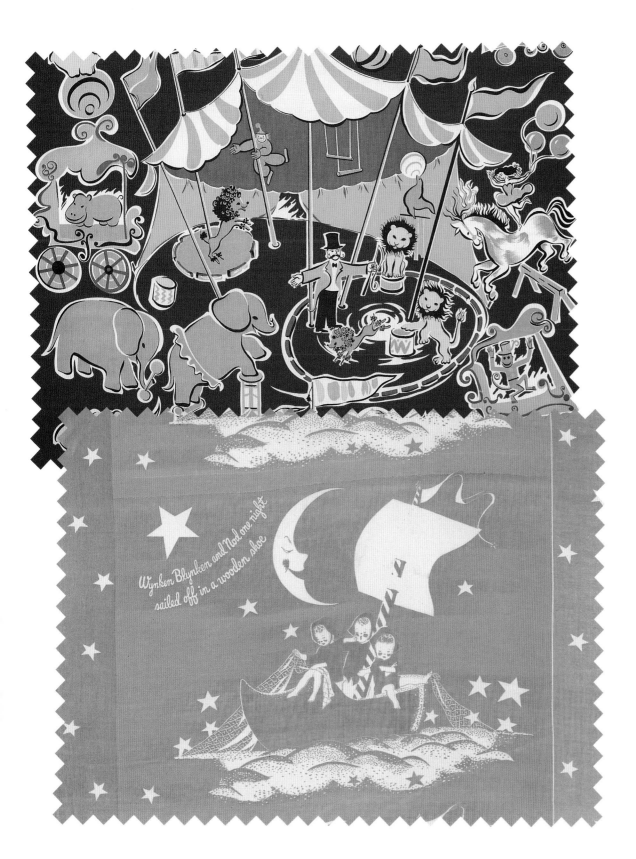

In the 1950s, the first decade to gear a significant portion of production efforts to the children's industry, manufacturers churned out specialty textiles, wallpapers, and furniture to stimulate the imagination of the postwar babies. Prints such as this riotous circus figural on sateen were intended for the nursery.

The nursery rhyme characters Wynken, Blynken, and Nod sail off in a wooden shoe on this figured chintz from the early 1920s.

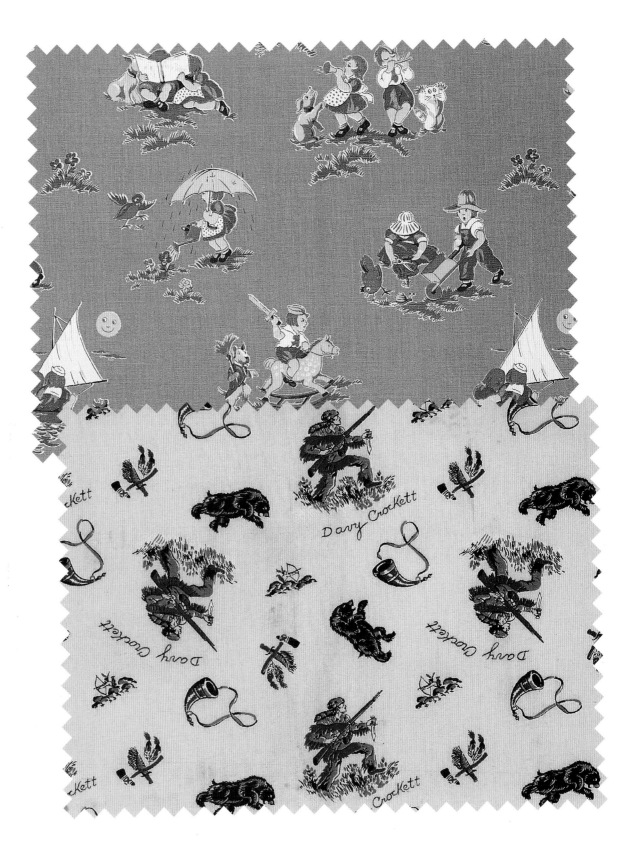

68 *The adventures of an enchanting pair of playmates are recorded on this canvas duck print from the early 1920s.*

A decade dominated by didacticism, the 1950s promoted an assortment of traditional and newfangled hero figures, in part as a marketing device to justify consumption of such non-essential mass market products as comic books and television sets. Davy Crockett figured on this linen-weave cotton intended for the young American boy.

Tin soldiers parade across hills and dales in this 1950s pattern which was also produced against chartreuse and yellow grounds.

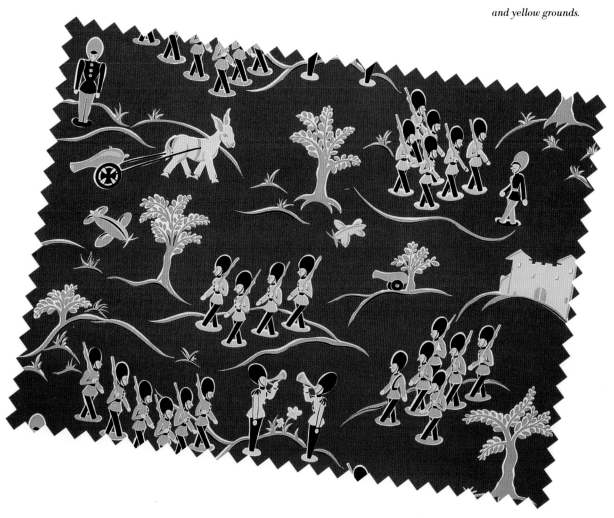

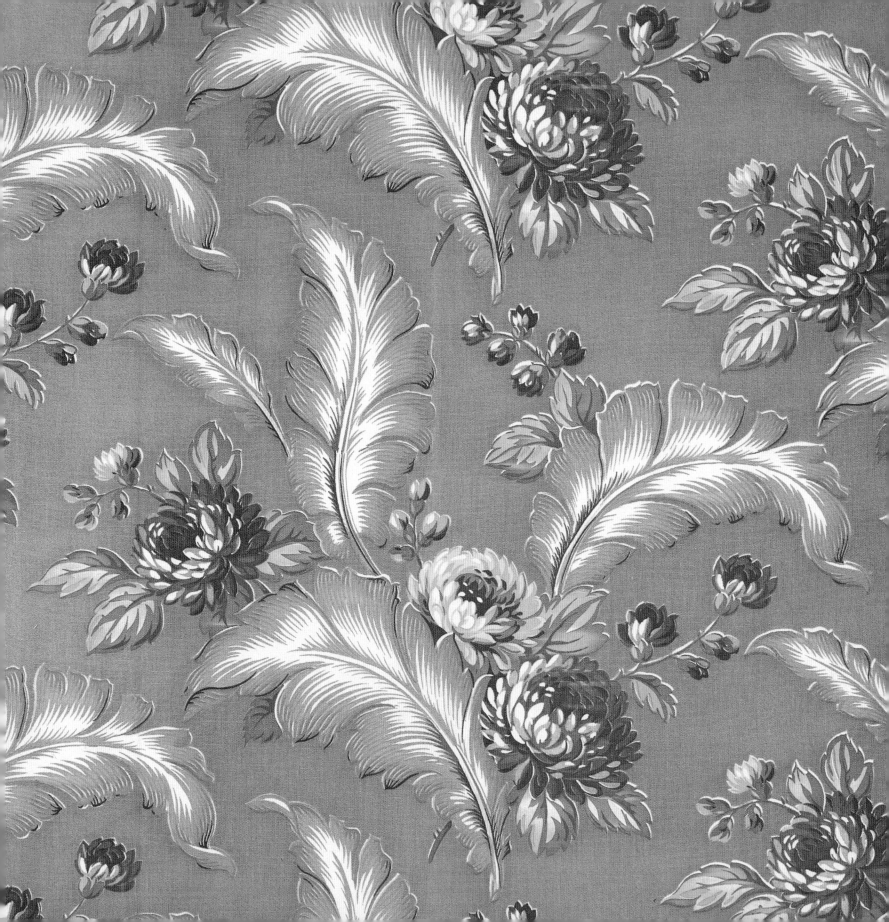

Hurray for Hollywood!

Some of the most exuberant and fanciful fabrics were produced during the years between the wars, particularly during the Great Depression. The floral fabrics of the 1930s were a case in point. Festooned with feathers, swags, and fleur-de-lis patterns, they were filled with a freewheeling spirit of historical borrowing that came straight out of Hollywood. The connection with the cinema was so explicit, in fact, that the style came to be known as Hollywood Baroque or, less often, neo-Baroque and Baroque Modern.

While Hollywood's influence on the textiles that furnished interiors was considerable, it was negligible on other features of interior design. The sets created for musical extravaganzas were far too complicated to serve as practical models for home design. But the era was rich in films with historical themes that re-created the past with a considerable degree of period accuracy. For contemporary dramas, pseudo-eighteenth century textiles were teamed with anonymous period furniture whenever a suggestion of affluence or sophistication was required. Although the film studios recycled the same props over and over again for economic reasons, filmgoers rarely noticed the repetition. Instead, they absorbed the message that feathers, flowers, and frills equalled romance, elegance, and class.

With their brilliant colors and the shimmer of sensuous damasks and glazed chintzes, furniture fabrics in the Hollywood Baroque style tickled the imagination with hints of the high life and of adventure in times gone by. Few of these theatrical textiles, however, were suited for traditionally masculine spaces in the home. Instead, they tended to be used for feminine rooms such as the bedroom, dressing room, or bath. Decorators and homemakers followed the lead set by actresses such as Mae West, Ida Lupino, Greta Garbo, Myrna Loy, or Jean Harlow, who furnished their homes in loose re-creations of Louis XIV or other period styles. When Hollywood Baroque textiles appeared in public spaces, they did so predominantly in restaurants, hotel lobbies, and nightclubs with pretensions to grandeur and swank.

By the mid-1940s, Hollywood Baroque had run its course. War-weary Americans turned their backs on styles that were too obviously rooted in European history.

72 *The Leana Mills damask from the 1930s is based on a centuries-old French motif.*

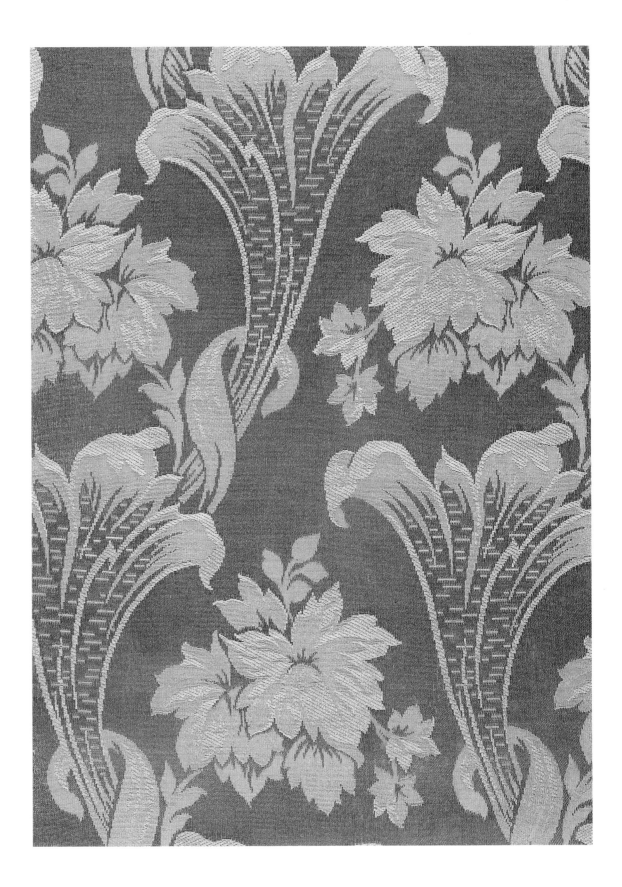

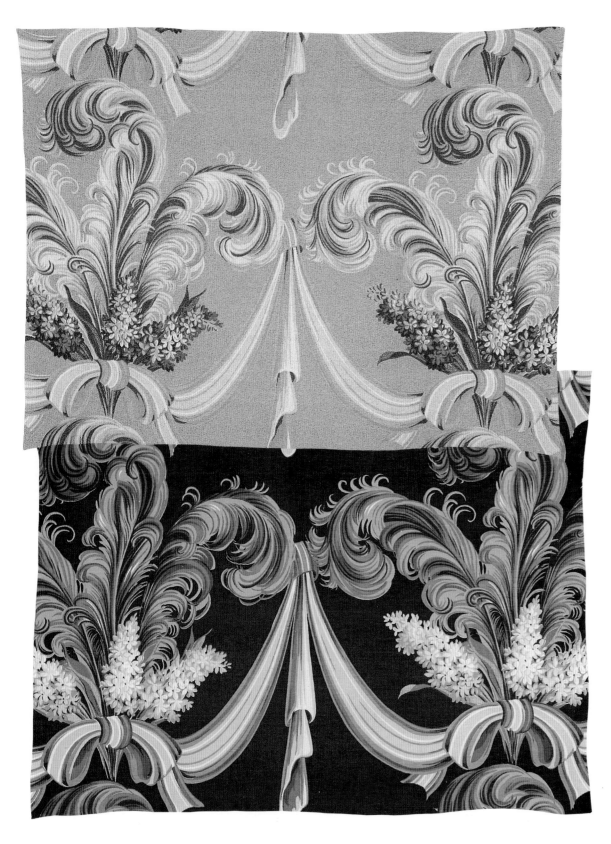

Very Dorothy Draper in scale and 73
impact, this bouquet of plumes and
lilacs is linked by swags and bows. The
pattern appeared in three colorways,
or grounds, on barkcloth.

74 *Tropical patterns became a fad in the late 1930s and remained popular well into the 1940s as a reflection of America's growing interest in its neighbors to the south and its military involvement in the Pacific. This late 1930s barkcloth, available in black, white, and chartreuse grounds, features an atypical combination of tropical foliage with plumes and highly stylized partridges.*

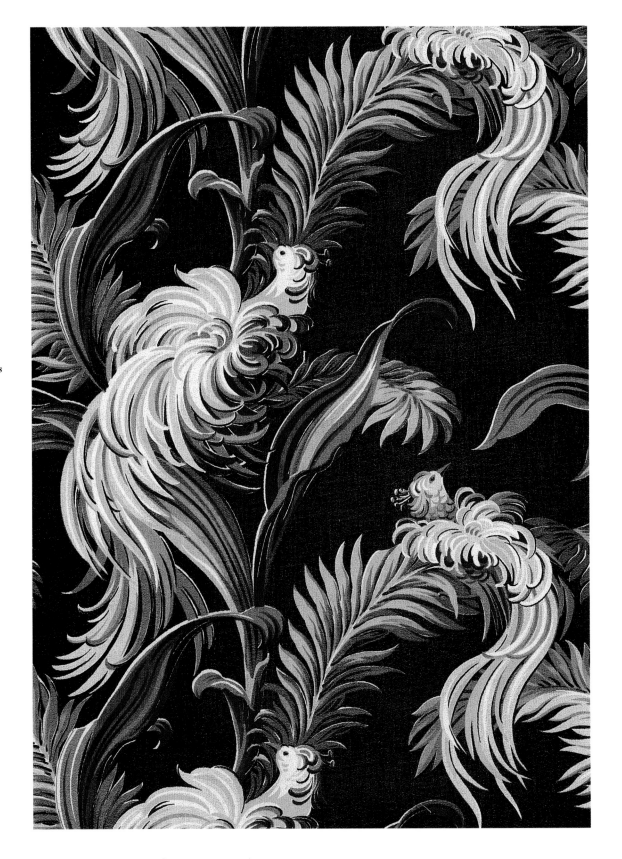

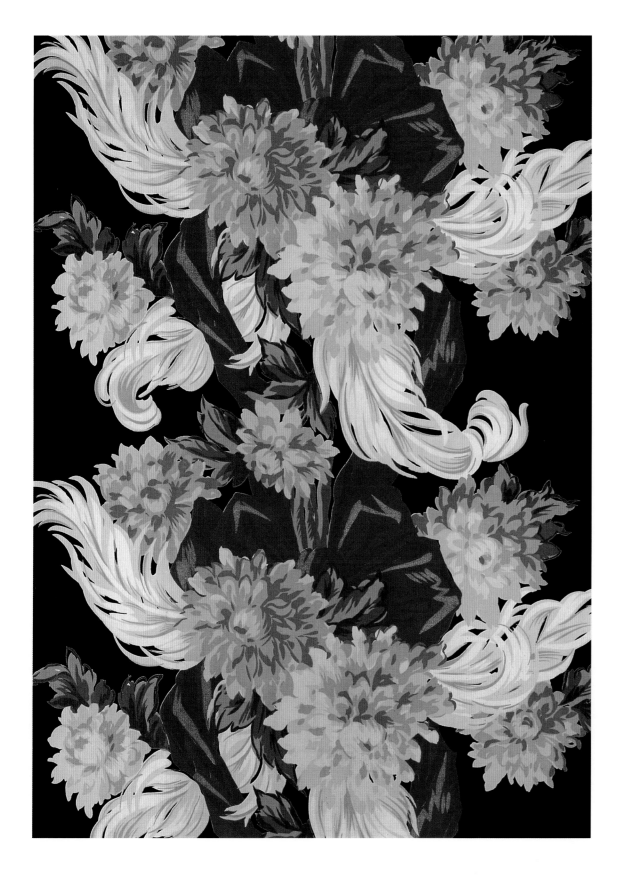

Highly ornate neo-Baroque designs were used principally in hotels, restaurants, and nightclubs whose patrons, in the words of an American journalist writing in 1945, "don't want to feel functional, they want to feel Grand." One such grand textile was "Regency," a highly polished chintz incorporating mums, ribbons, and plumes, produced by Waverly on black and chartreuse grounds.

75

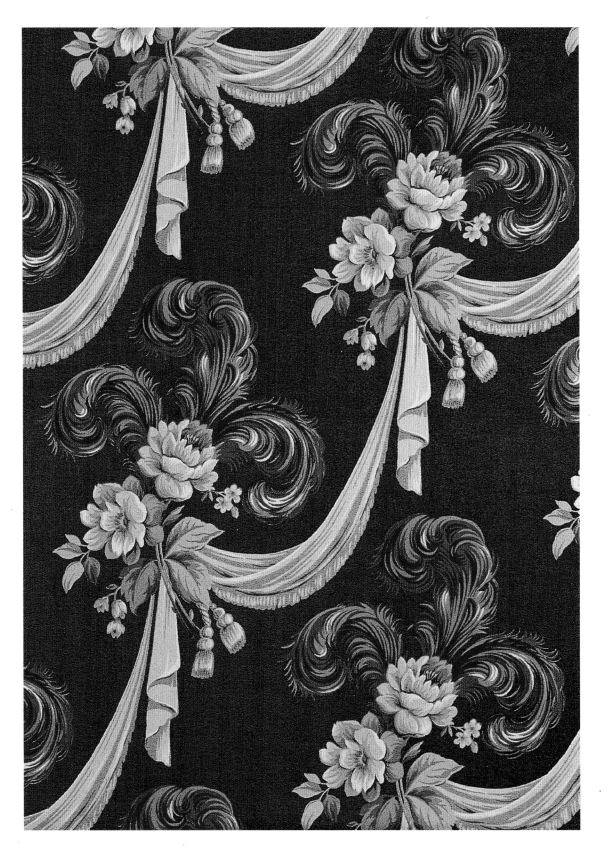

This outstanding example of the neo-Baroque reveals a postwar shift to chartreuse and rose tones, colors that migrated to dinnerware after 1945.

Clockwise from top left
Dating from 1928-32, this glazed chintz interprets the traditional sea-shell motif in the spirit of decorative formalism inspired by Hollywood.

Marie Antoinette had used plumes in textiles she designed for her château, Le Petit Trianon. This circa 1928 barkcloth was produced in blue and gray grounds as well.

"Festoon," a circa 1924 Puritan Vat Print, is a stunning example of a bengaline weave. The formal arrangement of the swags, in combination with pastoral bouquets, is characteristic of the era's fascination with eighteenth century revival styles.

Ostrich plumes adorn English roses in this diminutively scaled diamond weave from the early 1930s.

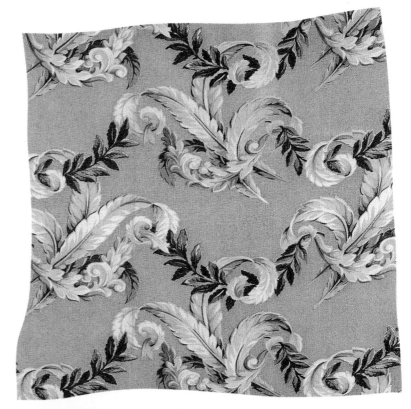
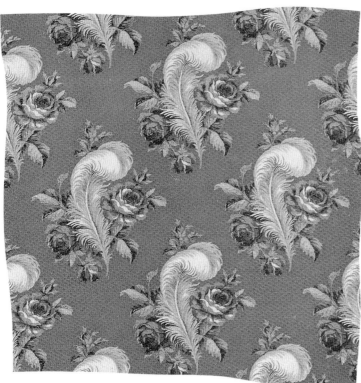
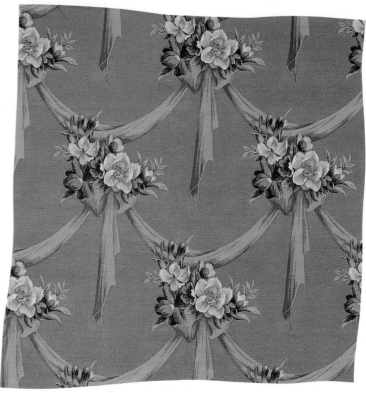

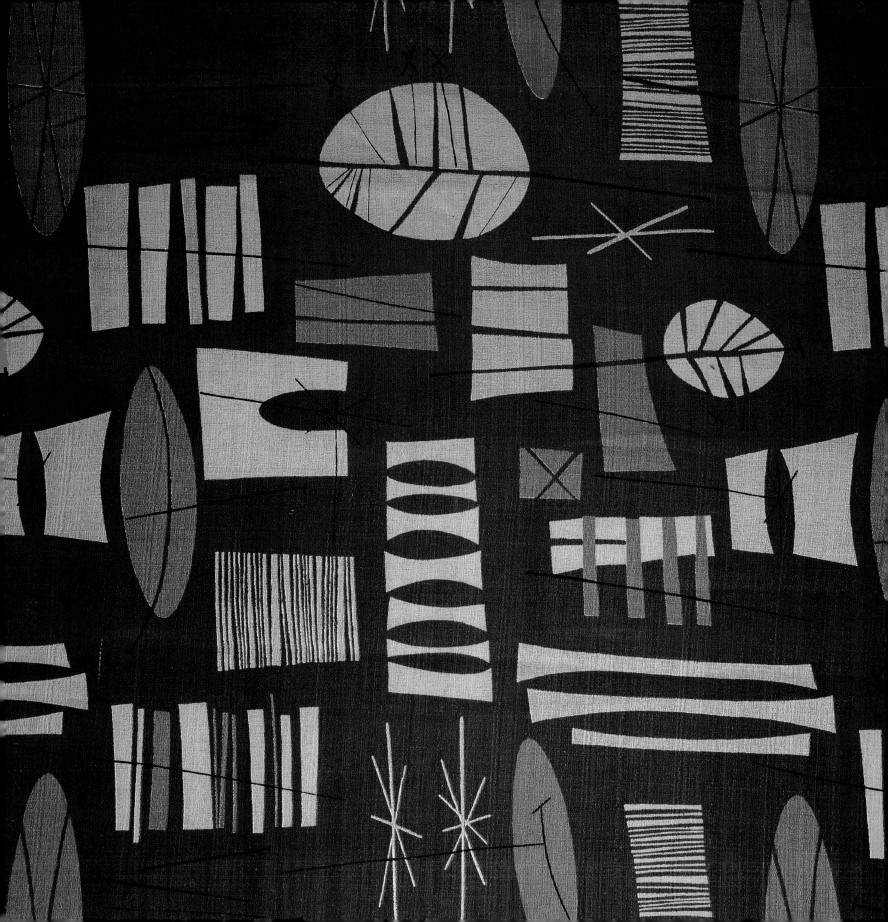

One of the most interesting groups of textiles to surface in the postwar period merged traditional motifs with the new, sophisticated design vocabulary of abstraction. Variously described as organic or crossover, this genre came out of the studios of textile designers who were eager to experiment once again with ways of "modernizing" traditional floral prints. While stylistic changes had been slow in coming during the mid-1940s, by the end of the decade experimentation was rife.

The organic style derived its inspiration from nature. Unlike the more radical experiments of the time—which presented nature at a submicroscopic scale not previously revealed—these crossover fabrics preserved a more or less literal approach to the subject. The nature they imitated tended to be projected into a realm of abstracted Platonic forms. For designers working in this mode, representation was not a matter of literally transcribing a leaf, say, or a seedpod, but, rather, of grasping the abstract geometric form underlying the actual object.

Irregular cupped or serrated leaf shapes were linked by delicate networks of stems and squiggles to simple amoebic forms. If they seemed far removed from their original inspiration, they were actually no less bizarre than their more naturalistic alternatives, which were often depicted in a highly unnatural palette of colors. The combination of muddy hues and sharp, acid colors was perceived to be as avant-garde as the motifs. Equally avant-garde were the typographical and calligraphic elements, which were borrowed from the visual language of science and engineering to unify floral and geometric shapes.

Much of the impetus for the organic style came from Scandinavia, largely through the efforts of Knoll International, which began introducing Scandinavian furniture and fabrics into the United States in the early 1940s. Furniture such as the chairs by Mies van der Rohe and Marcel Breuer, as well as printed textiles, found a ready market among corporate clients and the well-heeled design-conscious elite. Being easy to copy and relatively inexpensive to produce, the textiles were by far the most influential elements of Scandinavian design to penetrate the average home.

Calligraphic swirls, geometric forms, and scaled-down leaves are combined in this circa 1951 barkcloth, reconciling two previously divergent motifs. *(top)*

By the late 1940s, designers began to experiment with new materials and motifs. Abandoning the tropics, they headed for the woods. Shadowing became popular and lightweight materials were favored over barkcloth. *(bottom)*

Despite its moody tonalities, this circa 1950 barkcloth sustains a lyrical mood. *(right)*

80

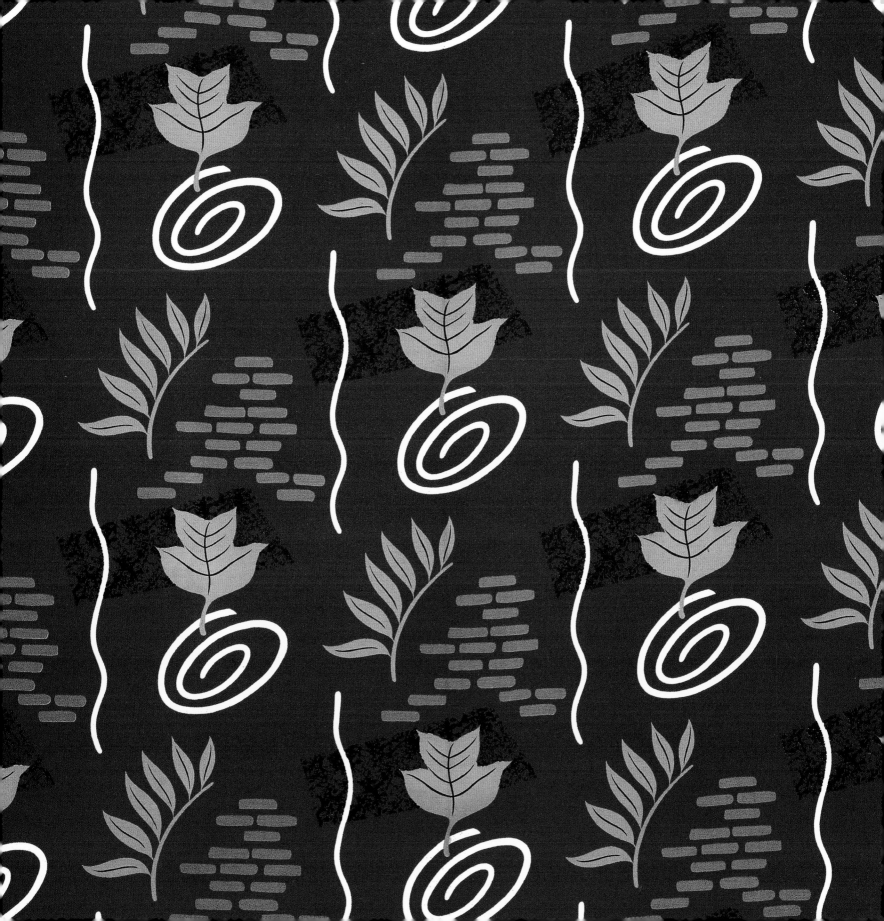

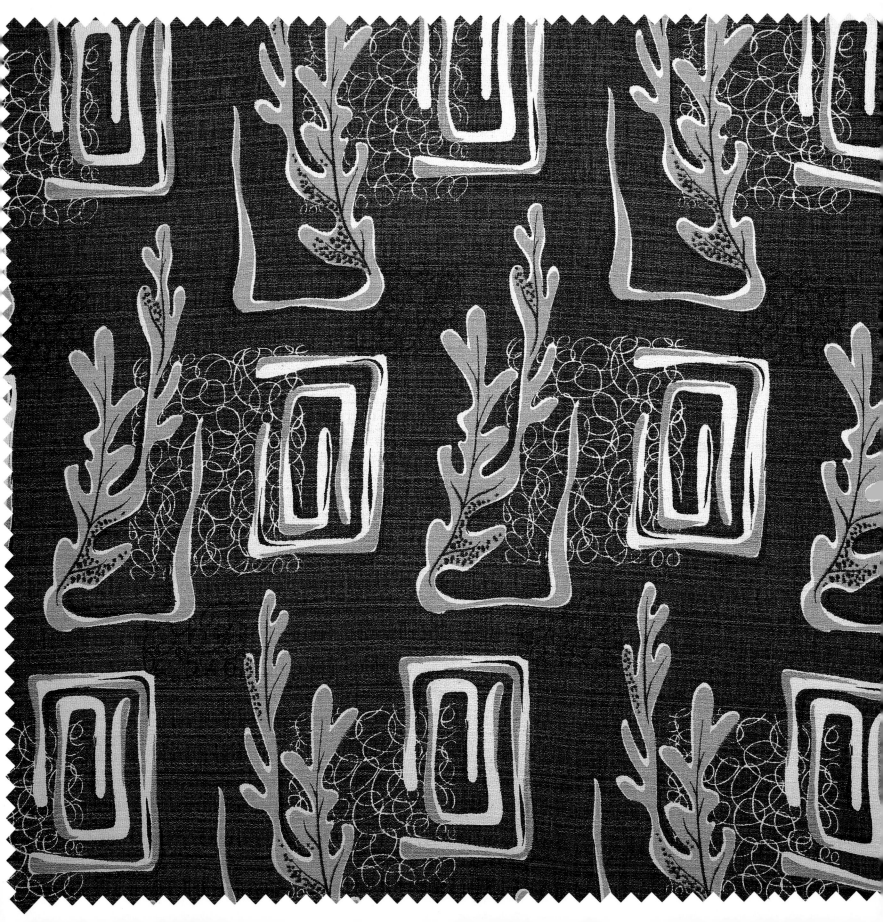

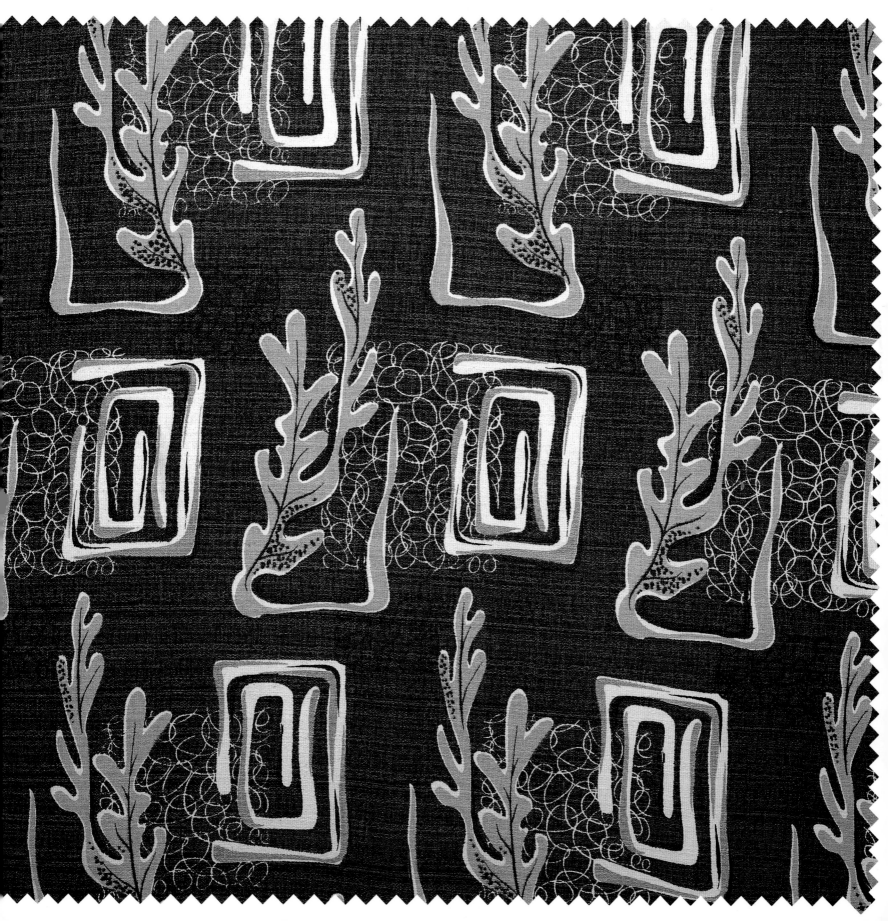

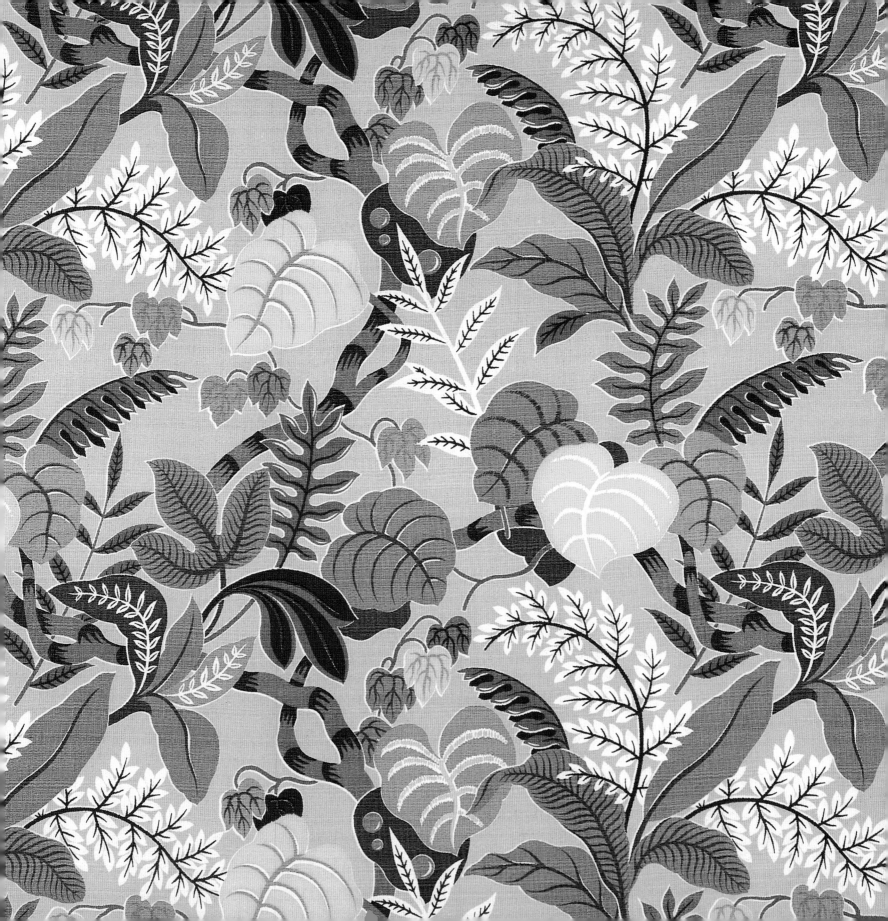

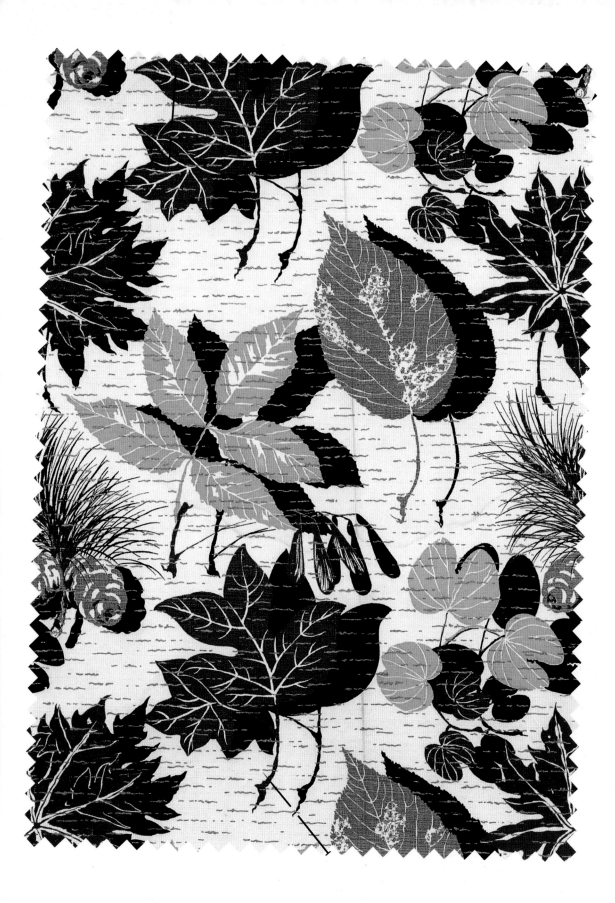

The pine cone, aspen, and maple leaf pattern of this textile is typical of the woodsy motifs that were in vogue for a brief period in the post-World War II era. The design is rendered in the palette typical of the 1949-50 season, which antedates the atomic delirium decade. The use of shadows and of gold powders in the printing process is distinctive. (right)

The organic style, characterized by lush vegetable forms crowding the visual field, had been introduced into Swedish printed textiles during the early years of World War II. It appeared in American design in the postwar period in textiles such as this circa 1947 print. (left)

In the late 1940s and early 1950s, designers experimented with merging two concurrent, but distinct styles by combining organic and geometric motifs. This handsome print from the period successfully melds the two, using calligraphic line as a unifying element. (preceding pages)

85

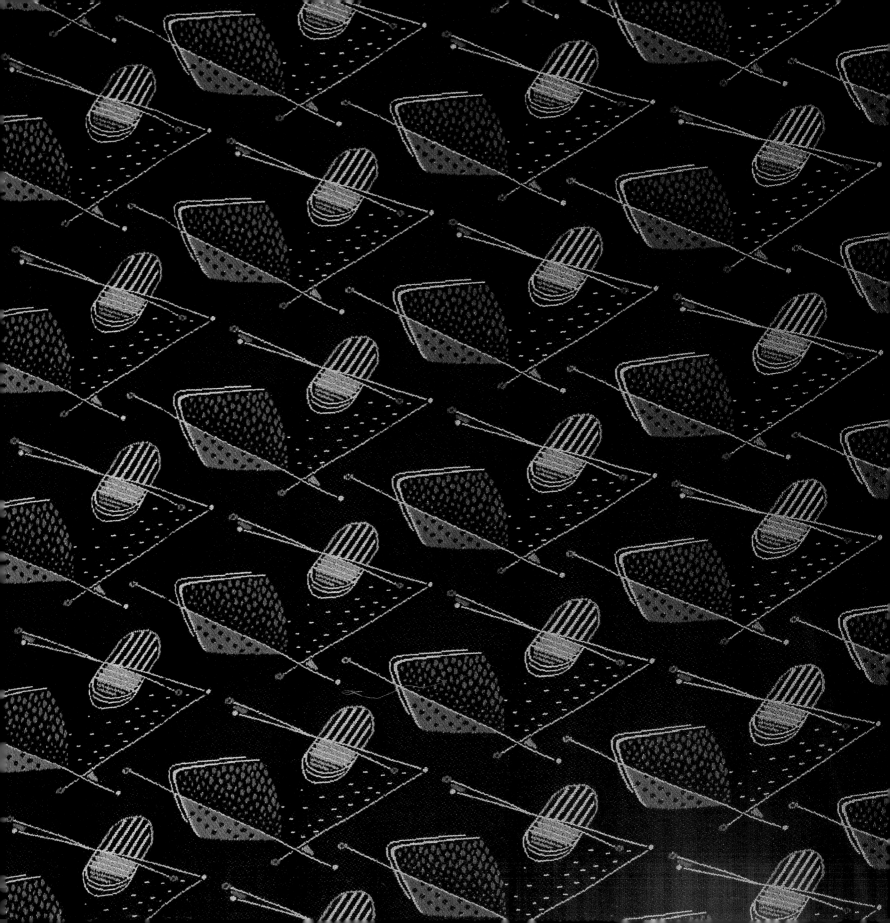

Seen against the backdrop of twentieth century textiles, 1950s fabrics—with their aggressive abstraction, organic swirls, and dimly representational shapes—stand out as unusually cerebral. In fact, their imagery seems far too demanding for the drapes or couch cushions for which the fabrics were intended. The best of these patterns echo the visionary aesthetics of some of the most progressive designers and architects of twentieth century modernism. Produced in a decade that gloried in the primacy of all things "Made in the USA," these textiles are refreshingly cosmopolitan in spirit.

As Europe began to mobilize for World War II, the United States became host to a stream of designers, architects, artists, and teachers fleeing repression and bringing with them new design ideas. Walter Gropius, Mies van der Rohe, László Moholy-Nagy, and other eminent representatives of the Bauhaus in Germany trained new generations of American furniture and textile designers at Harvard University, Armour Institute of Technology, Cranbrook Academy of Art, and Black Mountain College. As the existing infrastructure of textile printing firms seized on the innovative designs, well-known department stores such as Bloomingdale's and B. Altman in New York sponsored exhibits that popularized the aesthetic and disseminated it to a public clamoring for the cachet of instant good taste.

By the early 1950s the Americanization of the Bauhaus was in full swing. Cranbrook Academy affiliates such as Charles Eames, Eero Saarinen, Harry Bertoia, and Florence Knoll were producing such hallmark designs as the "Womb Chair," "Chicken Wire Chair," and "Tulip Chair." Based on new forms, technologies, and materials, this lightweight furniture demanded its complementary look in decorative textiles. But while the chairs and couches produced by Herman Miller or Knoll International were steeply priced, the textiles that derived from the Bauhaus aesthetic were not. Thanks to new manufacturing techniques, avant-garde design was no longer the preserve of an elite few.

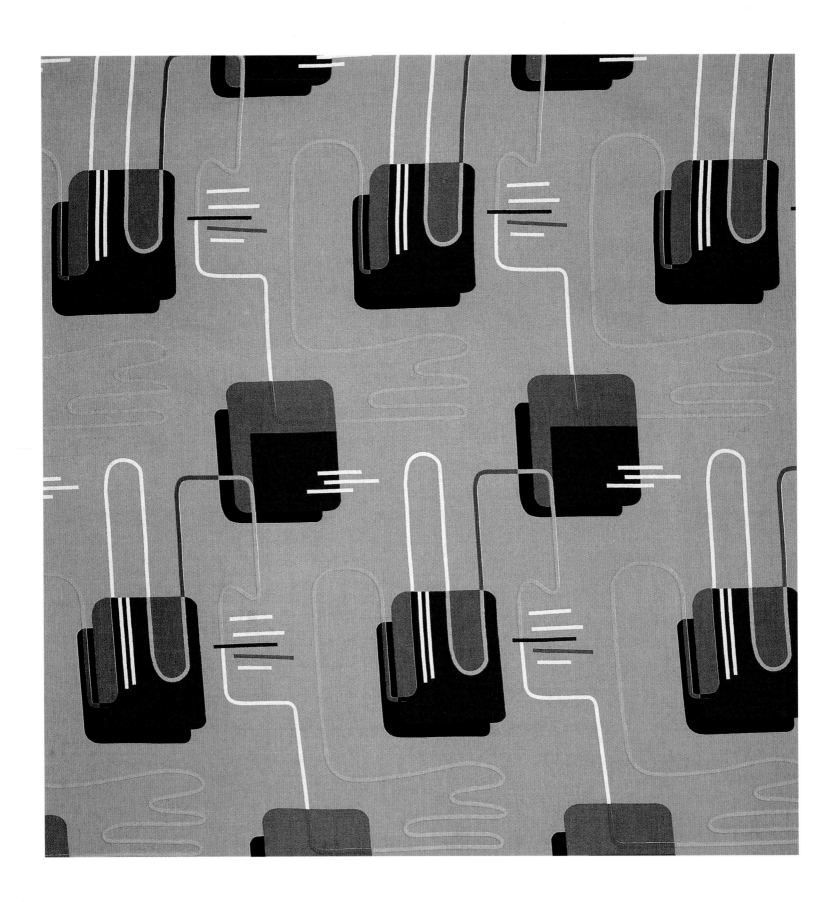

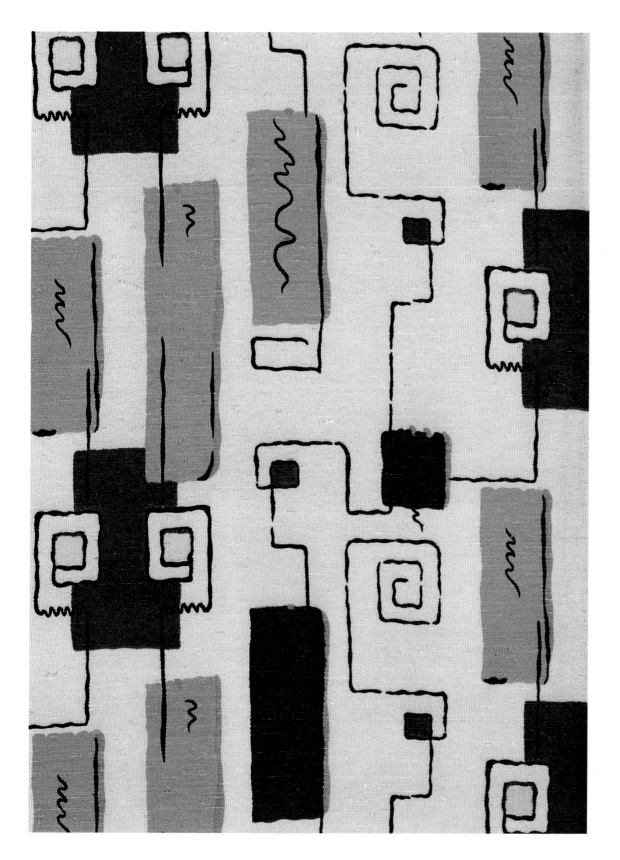

The geometric ornamentation and calligraphic lines are descended from Frank Lloyd Wright's textile and stained-glass designs. This slub-weave rayon-cotton blend dates from the mid-1950s. (right)

The obsessive preoccupation with material objects that typified the postwar era extended to enshrining domestic appliances as iconographic elements. The elegant design of this soft gray pebblecloth was inspired by the television screen and the roof-top antenna. (left)

Simulating batik blockprints, this textural pattern dates from the late 1940s. (following pages)

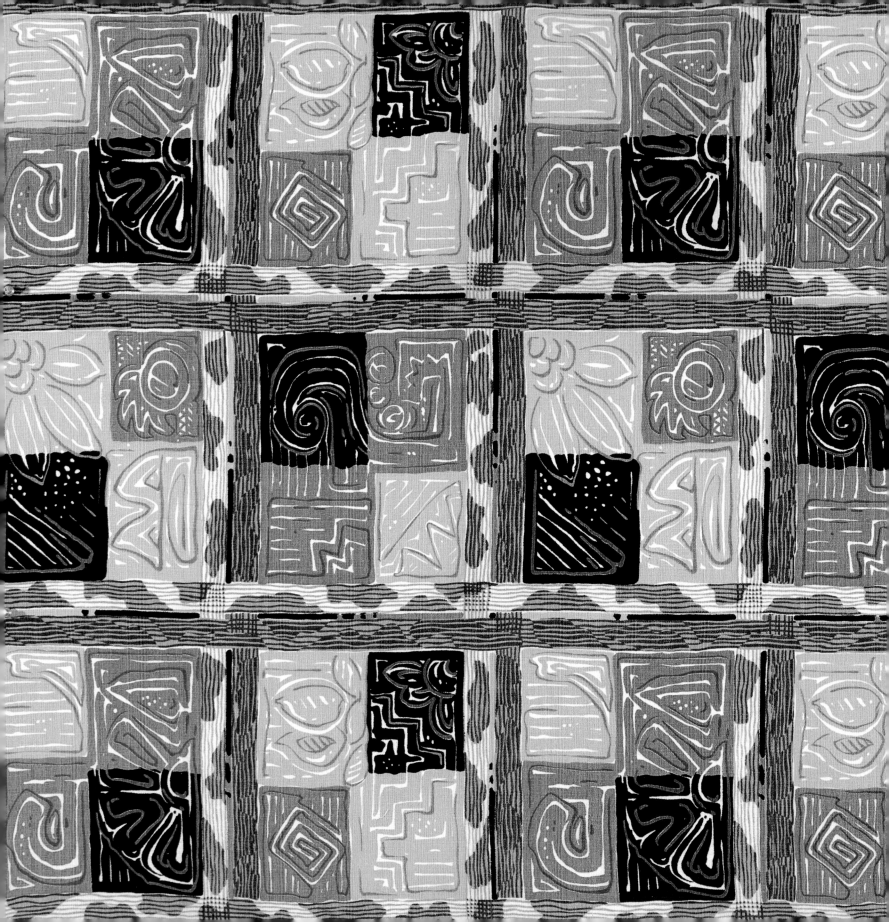

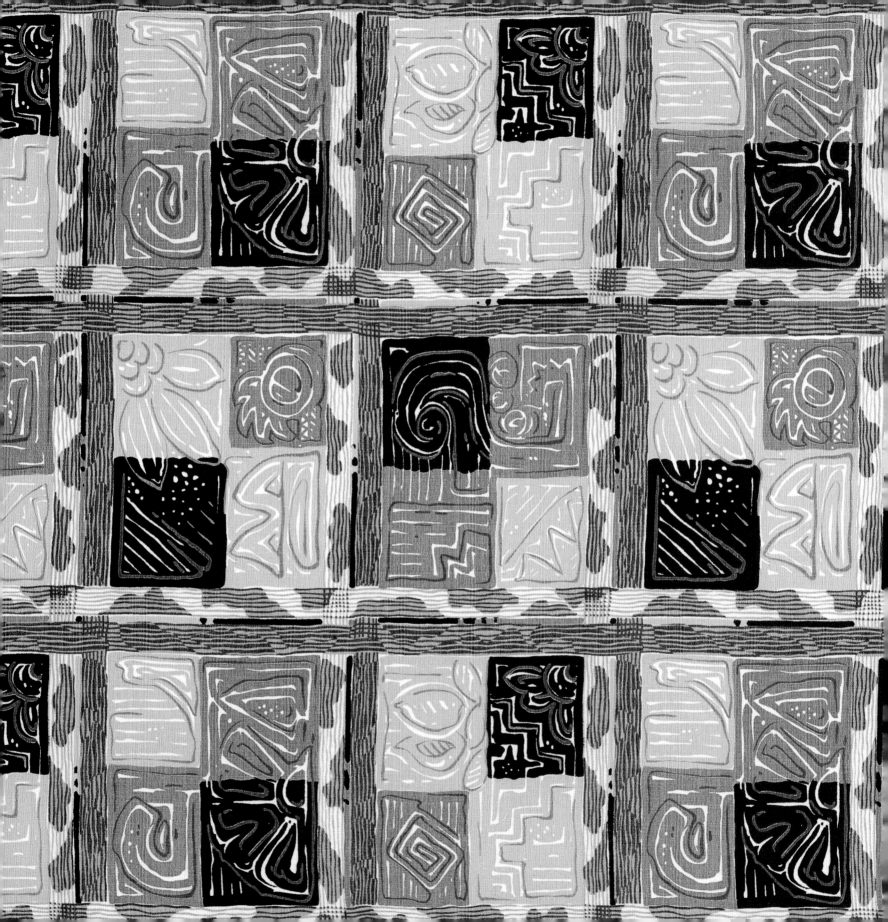

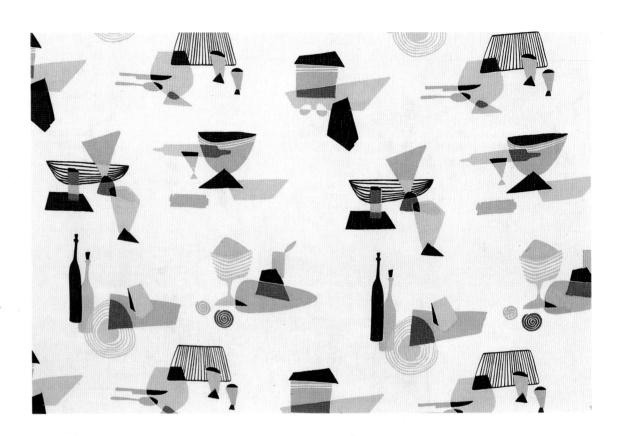

92 *Designed in the early 1950s, this honeycomb-weave in several color versions on white features one of many variations of the vase-and-bowl style so typical of the first half of the decade. Designer Ruth Adler Schnee has been credited with originating this style, as well as the pits-and-pods designs, for domestic uses. Her hand-screen printing workshop, set up in 1947, specialized in devising designs from everyday objects, many of which were shown in the "Design in Use, USA" exhibit at New York's Museum of Modern Art.*

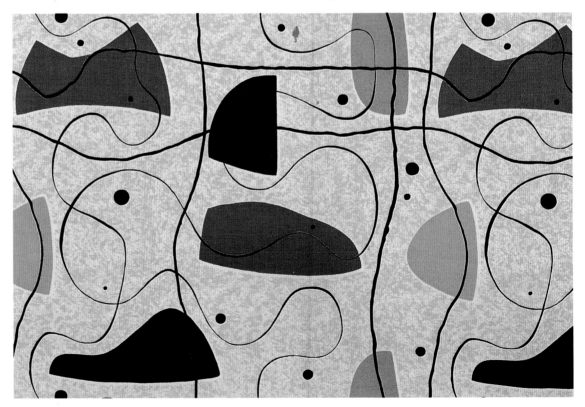

America's enthusiasm for scientific exploration and technological innovation found expression in patterns based on molecular structures and microscopic studies of plant forms and microorganisms. This mid-1950s pebblecloth, available in three colorways, suggests a scientific derivation.

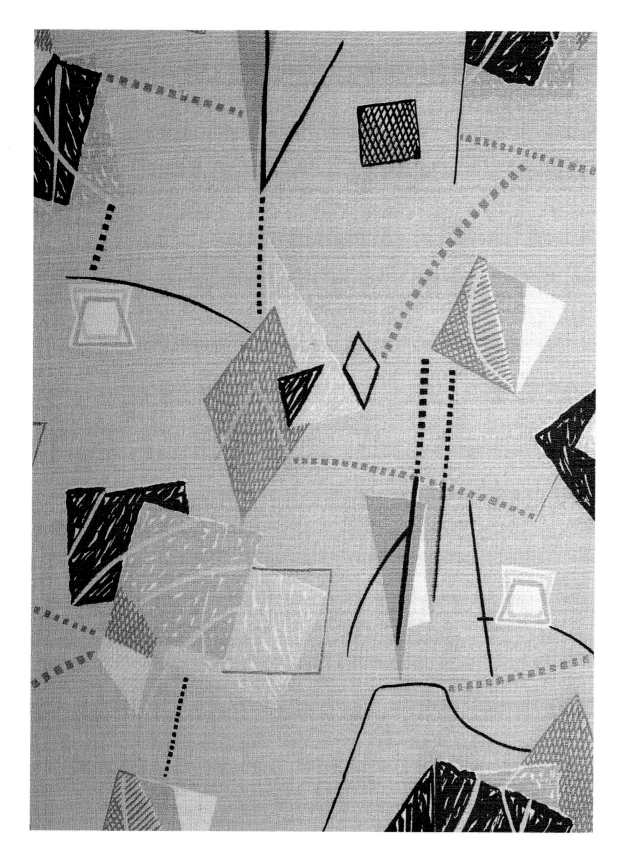

The fascination with bright colors such as turquoise blue, deep yellow, and bright orange throughout the 1950s was the result of the introduction and constant improvement of new dyestuffs. This textural birchbark from the early 1950s displays a stylish color palette consisting of Bermuda Pink, Lagoon Blue, and Dawn Gray in close proximity to metallic gold.

The transparent planes and rectangles pierced by openings evoke the surrealism of painter Giorgio de Chirico. While at first glance this 1959 print appears dominated by abstraction, closer scrutiny uncovers allusions to the icons of suburban life: doors, windows, passages, brick paths, and silhouetted automobile tail fins. *(following pages)*

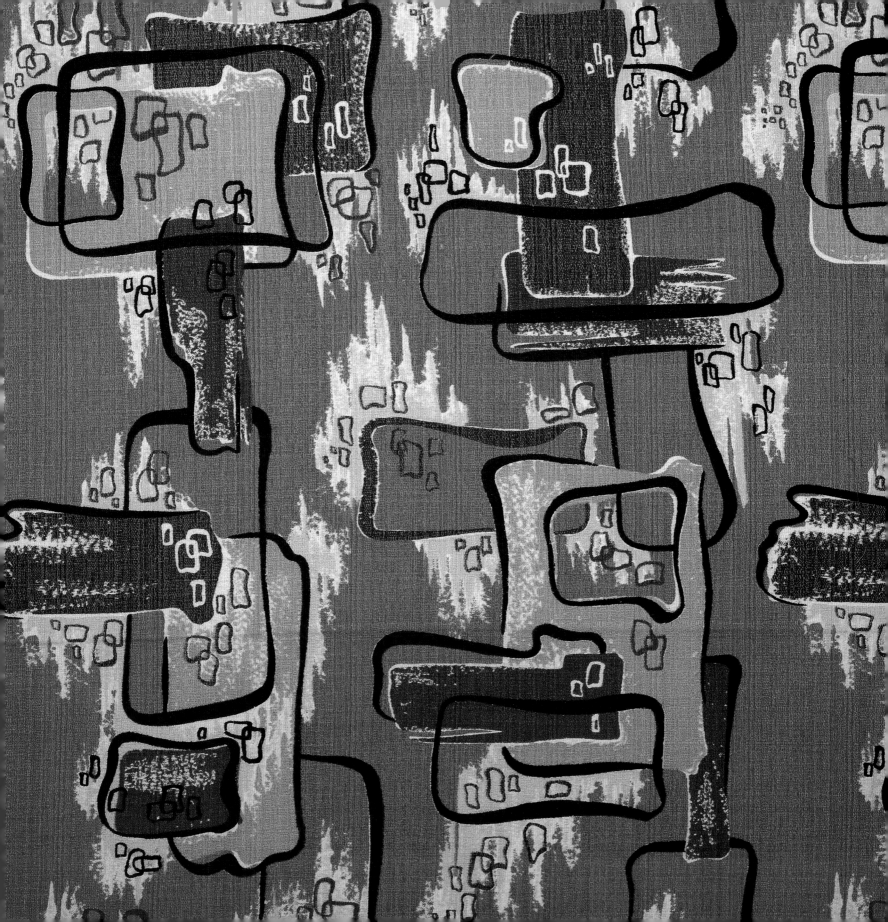

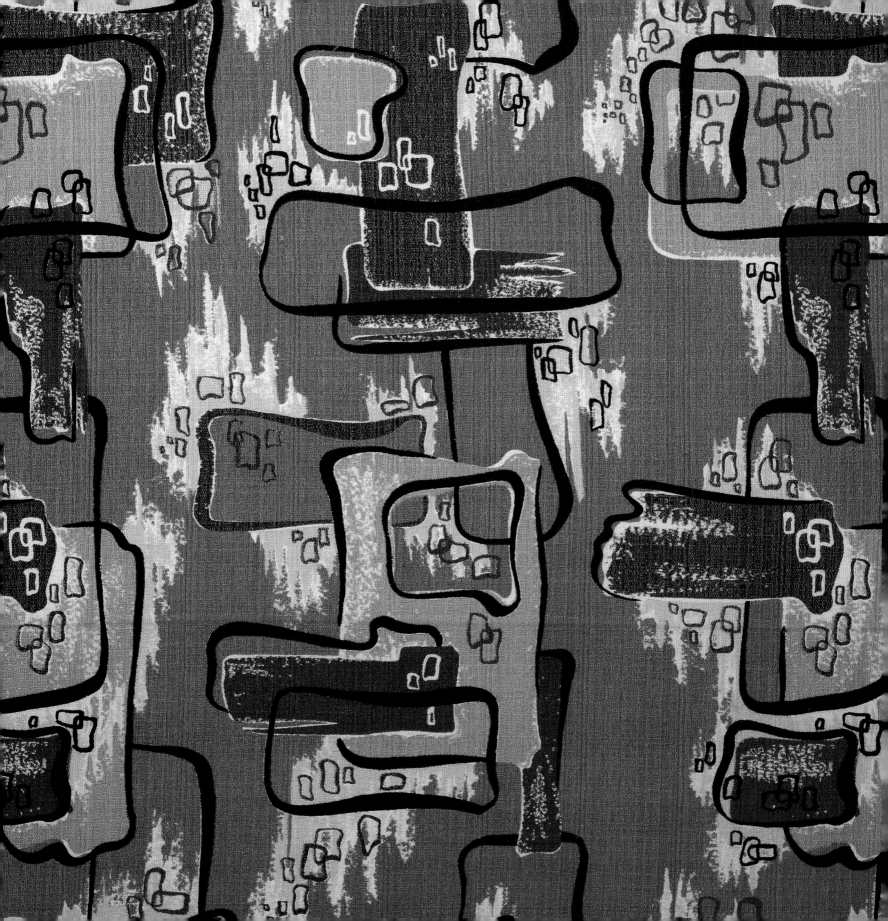

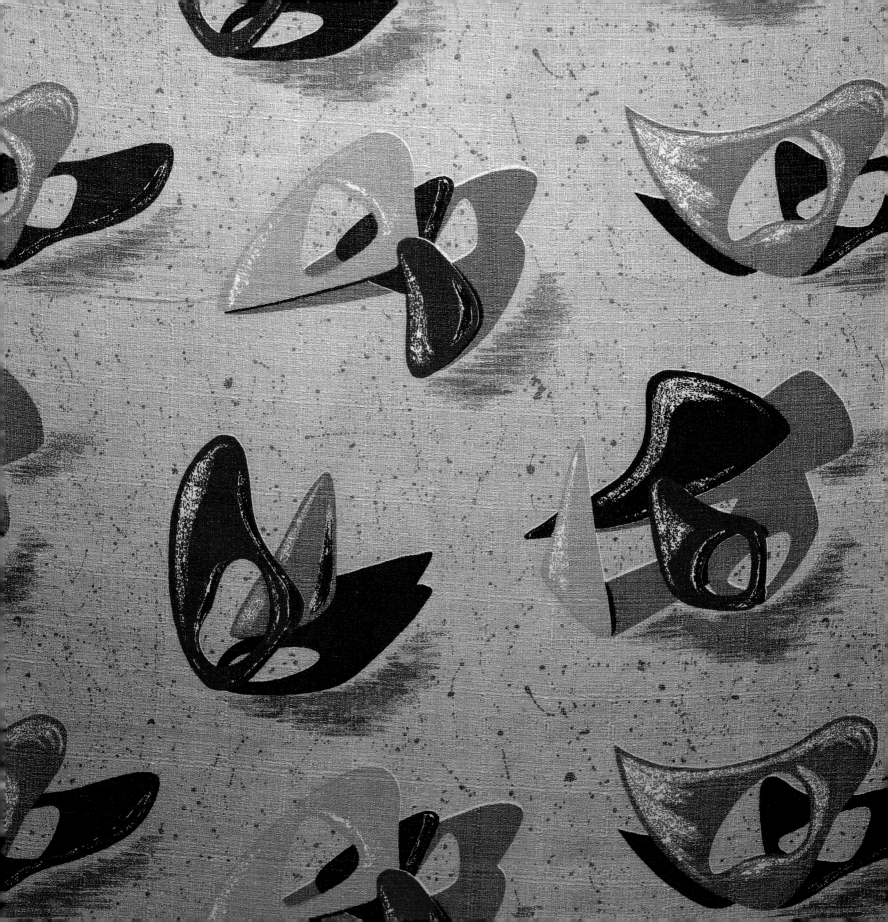

The drapery textiles of the postwar era were the milestones by which an America buoyed by optimism, idealism, and patriotism measured its prowess in the arena of domestic aesthetics and progressive design. Visionary and bold, the fabrics of the Truman and Eisenhower years enlivened both the suburban homes of returning GIs and the urban apartments of sophisticates.

With the end of World War II, as the massive work of dismantling a wartime economy got under way, architects, designers, craftsmen, and manufacturers were eager to find new products for a society flushed with the triumph of military conquest. The tremendous demand for housing and the beginning of an unprecedented building boom made the production of furniture, domestic appliances, and textiles for the home a natural solution.

The technological innovations contrived by the defense industry inspired a widespread conviction that everyday life would be transformed to its very foundation. Postwar automobiles were faster, bigger, more comfortable. Airplanes surpassed the speed of sound. Household chores vanished with the push of a button. Television augured an era of instant communication. Utopia, it seemed, had arrived. And the home of yesterday became an instant anachronism.

Suddenly, the consumer wanted a brave new iconography to complement the plethora of machines-for-living that were rolling off assembly lines in unprecedented color combinations. The flora and fauna that had been the staple of drapery and upholstery textiles declined dramatically in popularity.

Instead, an imagery based on abstraction, science, and fantasy began to proliferate on walls, windows, and metal-legged couches. Countless Formica countertops, linoleum floors, and drapes were patterned with amoeboid blobs, kidney-bean shapes, and boomerangs. Straight from a "Gay Paree" that was once again open to the tourist trade streamed pompon-bedecked poodles, berets, and the ubiquitous artist's palette. With a nod in the direction of highbrow culture, designs cued to the abstractions of Pablo Picasso, Jean Arp, and Joan Miró had tremendous snob appeal.

98

The 1950s penchant for glitter and for flamboyant juxtaposition of textures surfaces in this rayon-fiberglass groundcloth interwoven with gold Lurex. Like a Highlights *magazine puzzle, the pattern bristles with abstractions of Sputniks and galaxies.*

Harry Bertoia's wire chairs inspired a way of thinking about forms in space which are reflected in this birchbark print. This pattern was a likely candidate for the couch in the "rec" room, the shrine to familial bonding that abutted the carport, another 1950s innovation. (left)

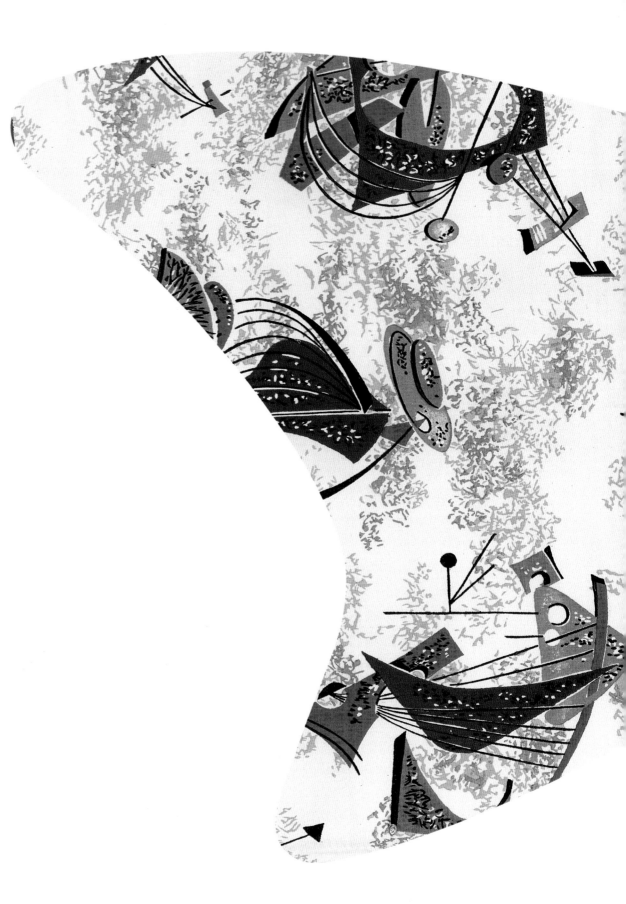

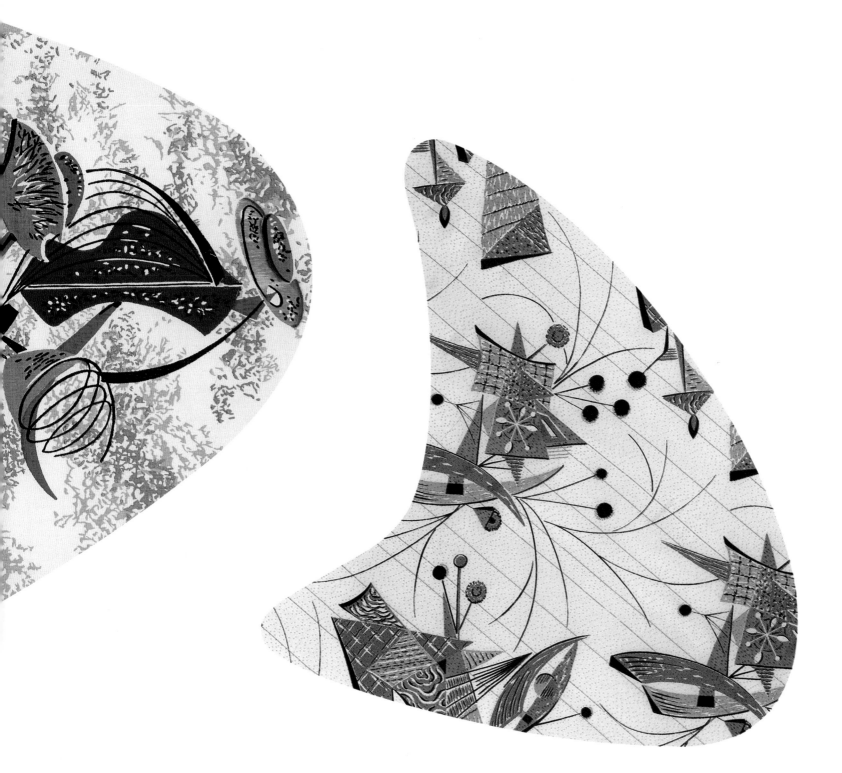

The wirelike shapes that played a dominant role in 1950s textiles mimicked the wire forms of furniture design. In this birchbark weave, floral motifs are reinterpreted as amoeboid blobs, with petals, stems, and stamens defined by wiry tracery. This fabric was available in white, chartreuse, brown, and black colorways, highlighted with metallic silver or gold powders. (right)

Jean Arp's assemblages found a distant echo in textile designs that juxtaposed fleshy boomerangs and his biomorphic shapes, as well as those of Miró, with a spidery swirl of spirals and sharp directional lines. In this birchbark, dating from 1952, gold metallic leaf was applied in the final printing stage. (left)

Based on the delta-wing jet aircraft, the boomerang was the signature shape of dynamism for a decade devoted to upward-and-outward mobility. A calligraphy of boomerangs— open, closed, intertwined, and swirling around hairpin curves—is interspersed with starbursts against a crinkled net pattern. (following pages)

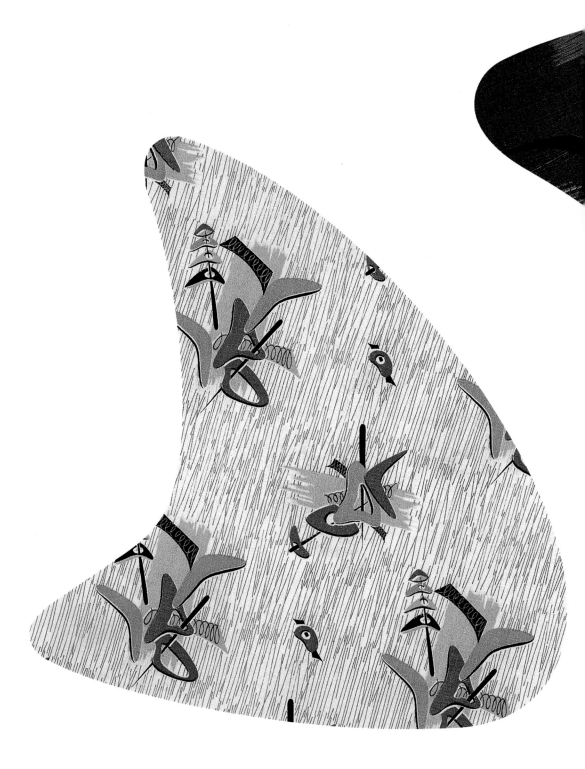

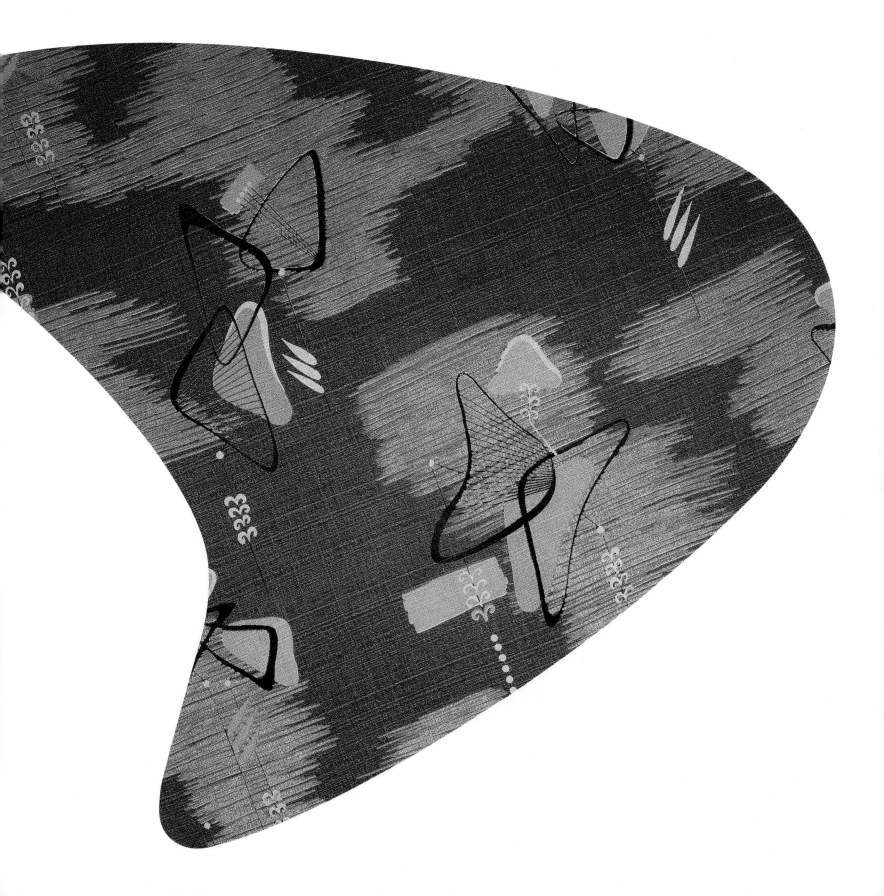

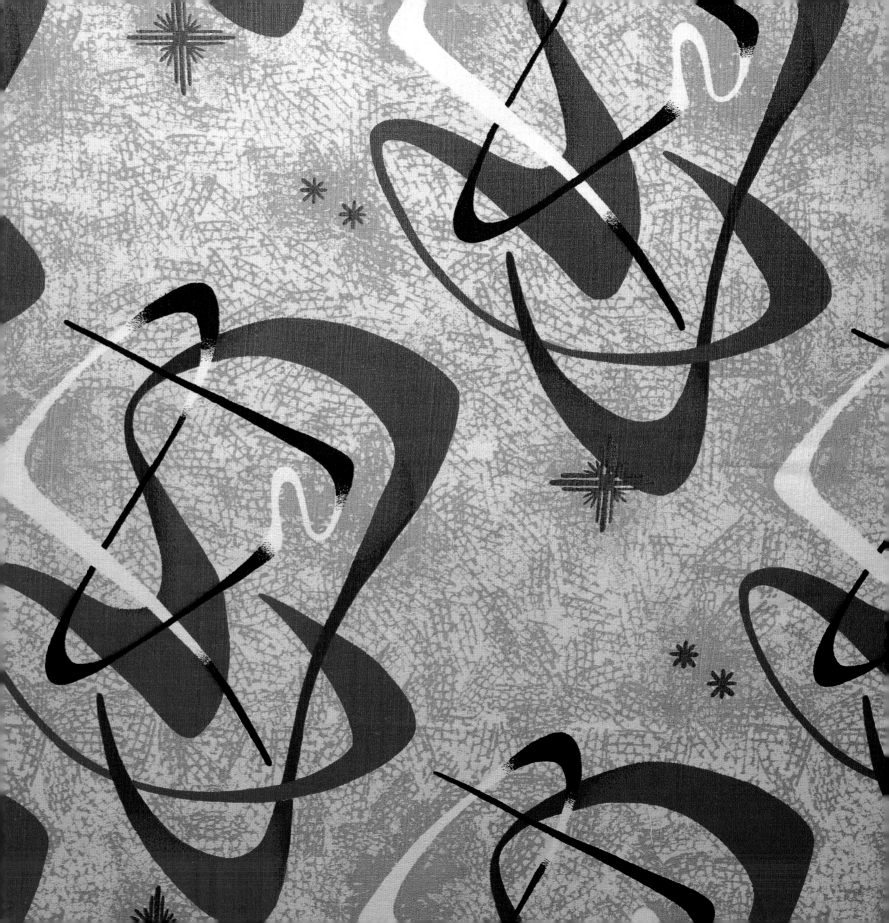

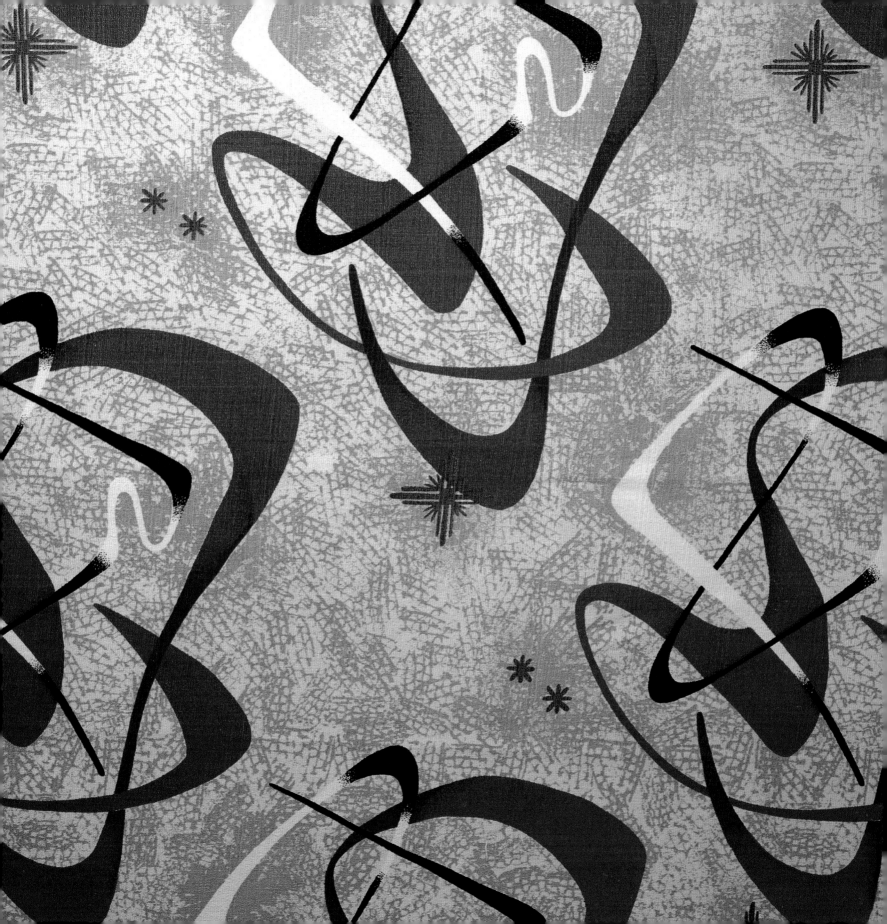

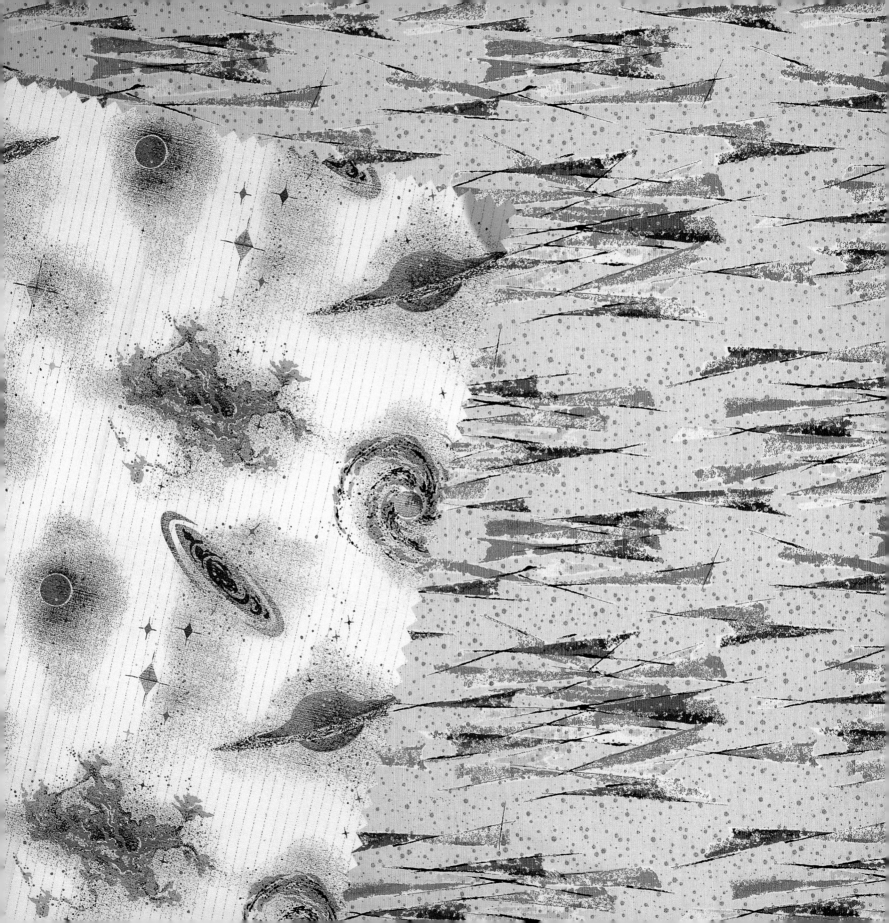

Americans of the 1950s were imbued with an almost mystical belief in the power of science to deliver the world from all ills. In interior design, too, Americans clamored for a scientifically—or at least rationally—derived environment. In their choice of decorative fabrics, they gravitated toward patterns that showed a rational bias or a scientific perspective. Natural subjects, such as animal and plant forms, were stylized, simplified, and sanitized. With their thin, spiky lines, these patterns complemented the graceful curves of chairs fashioned from thin steel rods by Henry Bertoia or the blond, rounded rock-maple and birch furniture by Heywood Wakefield.

Inspired by faith in nuclear energy, models of atomic and molecular structures inhabited everything from wall clocks to the curtains in dad's study. Satellites, starburst patterns, UFOs, and fantastic space probes blasted into popularity after the Soviet Union launched Sputnik. These extraterrestrial images had a strong masculine connotation that made them appropriate for seating and curtaining in the bachelor apartment,

In the open-plan suburban home, everything was keyed to movement. Small, airy textile patterns marked a departure from the overscaled prints of the 1940s. Nothing was to arrest the eye or wistfully recall past styles. The living room couch and drapes in particular strove to create the feeling of unfettered mobility, which was especially important in small tract homes.

Perhaps in counterpoint to the dominance of traditionally "un-aesthetic" imagery, 1950s textiles—particularly those intended for formal living areas—relied heavily on the use of silver or gold Lurex woven directly into the cloth, or metallic leaf and powder incorporated into the fibers during the printing process.

It was precisely the textiles imprinted with the stylized icons of utilitarian modernity—the television sets, cars, amoebas, flying saucers, and molecules—that first fell into disrepute as exemplars of kitsch during the 1960s and 1970s. The 1990s, however, are rediscovering them with a passion and parading them on a range of surfaces from designer ties to reproductions of vintage upholstery fabrics.

The 1950s veneration of the automobile, speed, and mobility bred a fascination with various images of freedom, such as floating boxes with asymmetrically placed cutouts, spirals, with their connotation of perpetual motion, and semipermeable membranes such as wood grain, suggestive of penetrable boundaries. This ephemeral pattern on broadcloth, dating from the mid-1950s, uses gold Lurex. (left)

The appeal of this intriguing late 1950s print stems in part from the enigmatic tension between the pure abstraction and the representational geometry of the pattern. (middle)

This graceful pattern of broken arcs, architectonic columnar forms, and cascading circles dates from the mid-1950s. (right)

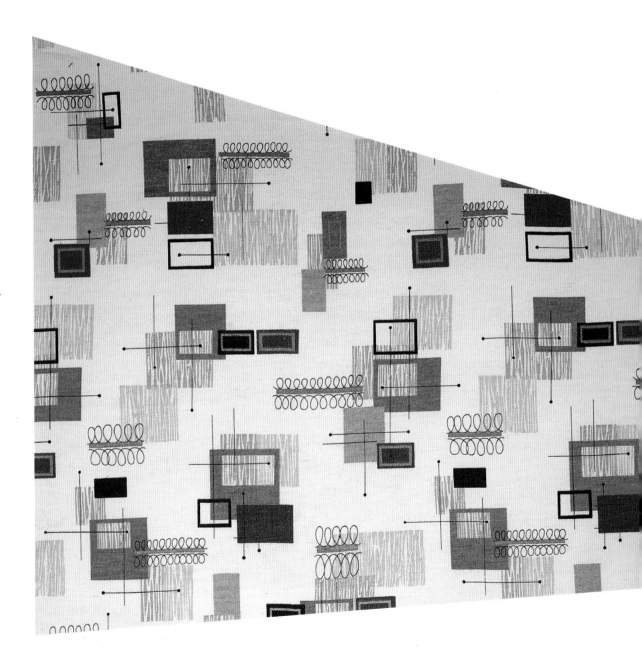

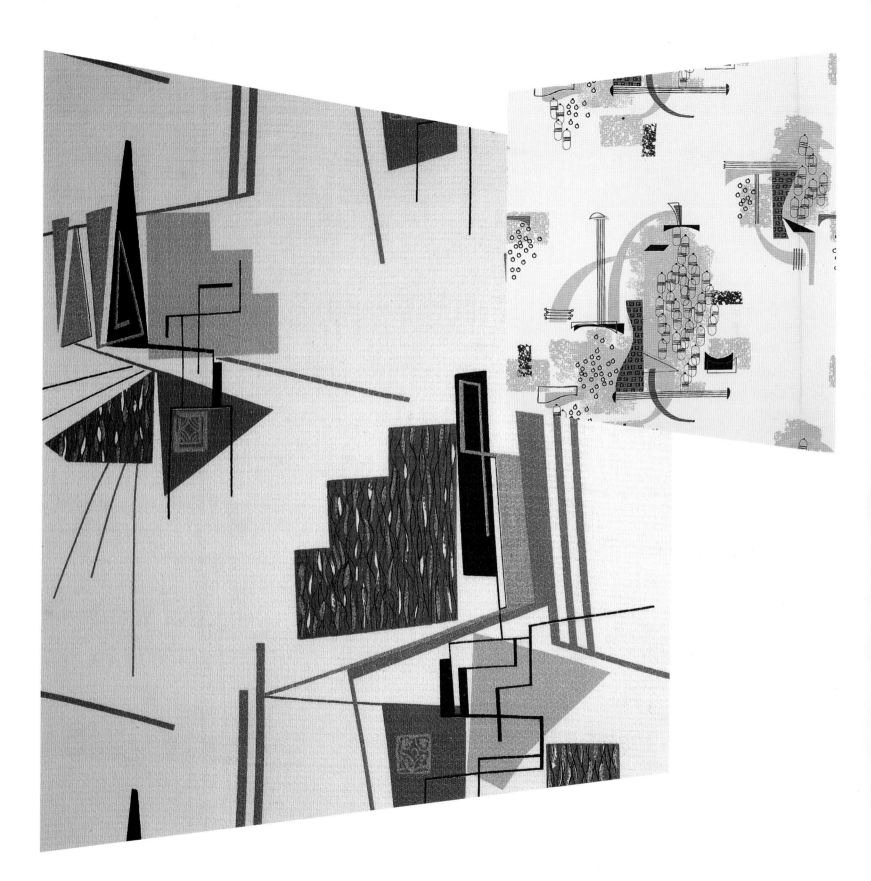

108 *This honeycomb-weave variation from the early 1950s uses small and colorful geometrics. A departure from the large-scale patterns of the 1940s, it was suited for covering the little windows in thousands of little Levittown homes sprouting up all over America during the postwar housing boom.*

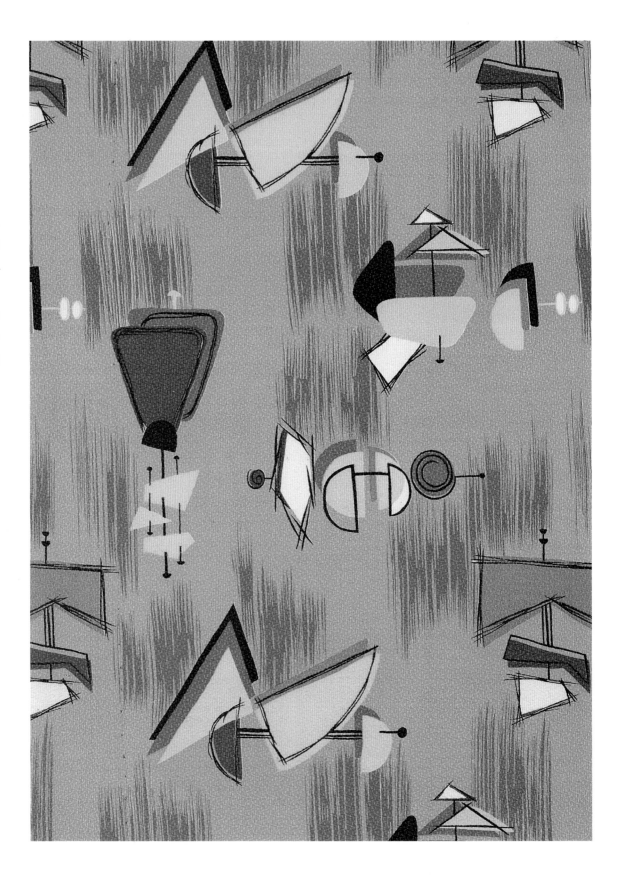

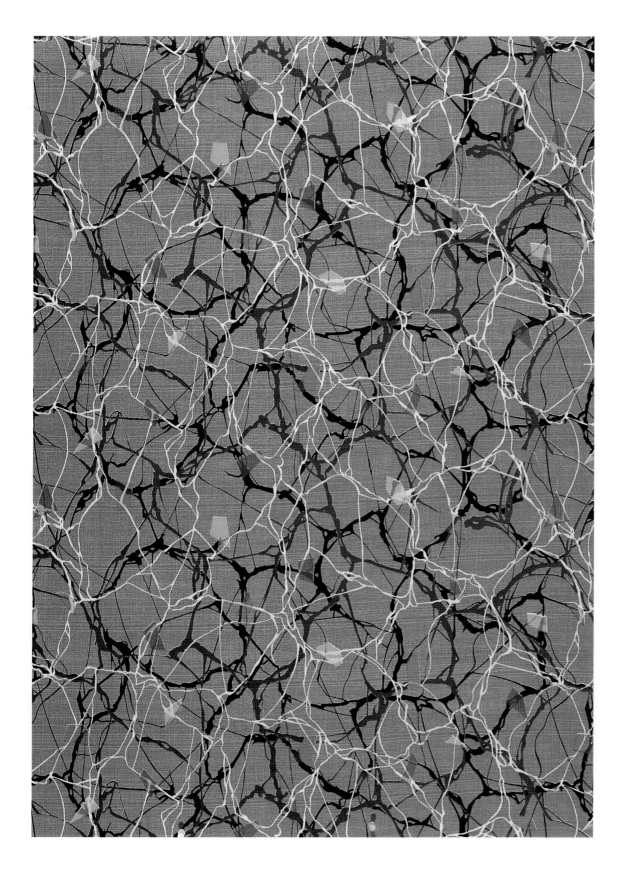

The 1950s love affair with science produced an aesthetic of the microscope which gloried in uncovering the hidden structure of things. This fabric, which superimposes the same spidery grids to create a sense of depth, is based on magnified cell structures.

110 *This pebblecloth from the late 1950s marks a radical departure from the cliched ducks-in-water motif that was a perennial favorite. (top)*

American cars of the 1950s visually and mechanically represented the grandness of the postwar era. In response, textiles such as this birch-bark weave paid homage to the automobile. (bottom)

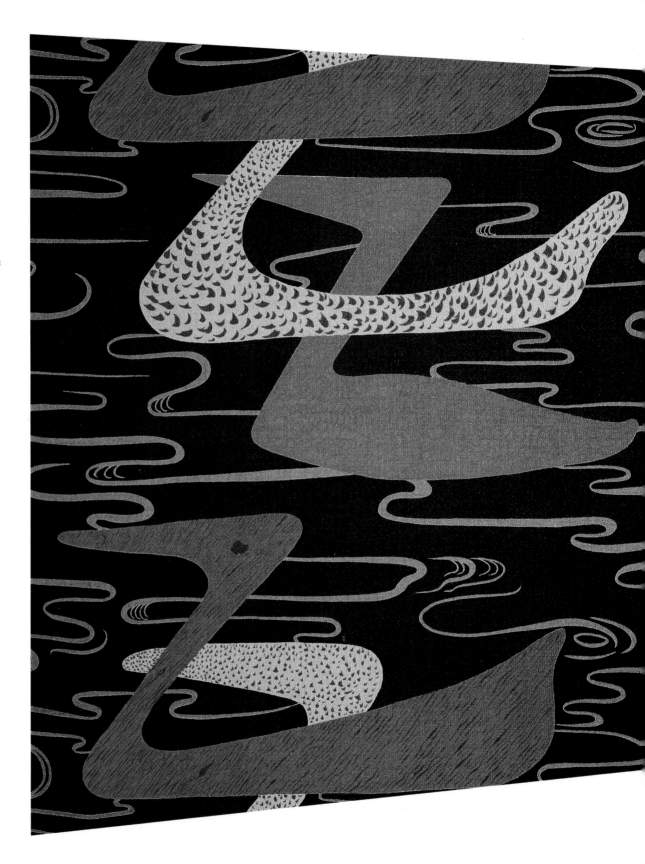

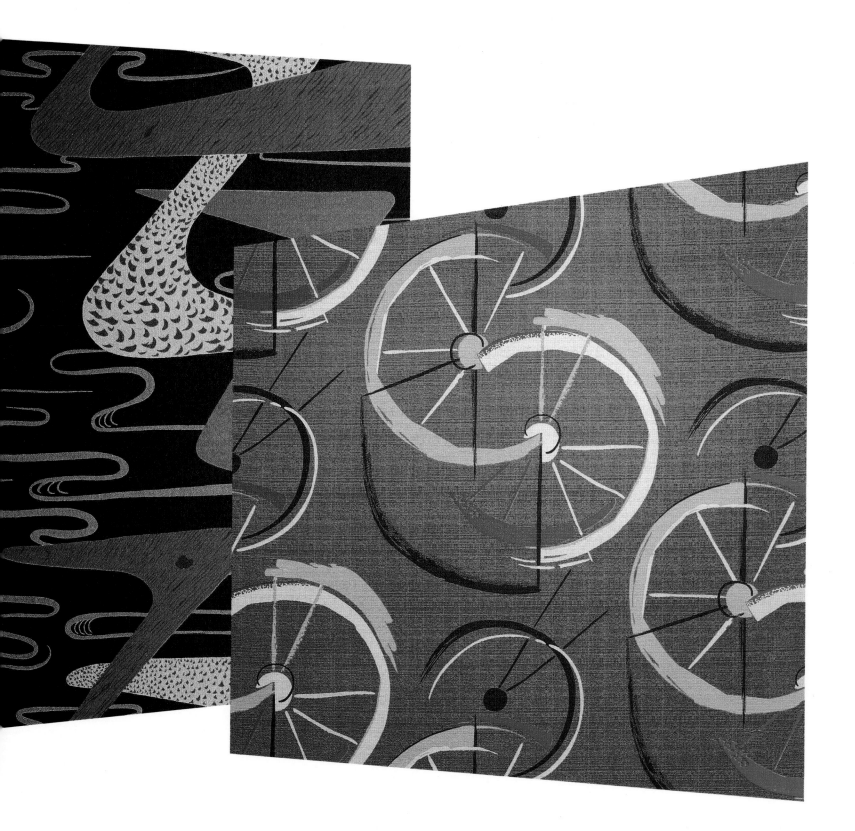

Chapter Opener
Captions

Cover

The "sensitive line" popular with graphic designers of the 1950s provides the star-burst axis along which a quixotic combination of futuristic and primitivist elements is ranged. The tribal geometries and wood-grain boomerangs reference the design to aboriginal culture, while the atomic clusters and delta-wing triangles tap into high technology.

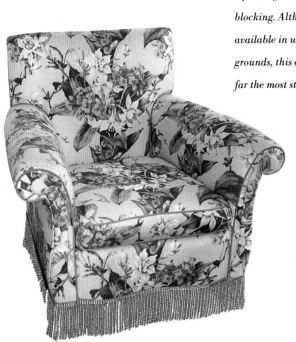

Page 1

Available at B. Altman in 1949, this barkcloth is an outstanding example of the organic school of textile design.

Pages 2-3

The "modern" look of this circa 1951 heavy flannel-finish sateen derives in part from the superimposition of a primary color such as white on the background to create the pattern, a printing technique known as overblocking. Although the design is also available in white and hunter green grounds, this chartreuse version is by far the most striking.

Page 4

Impaled to a simulated marble background, a swarm of fabric swatches shaped like boomerangs, blobs, triangles, and artists' palettes recapitulates the signature forms of the 1950s, which also migrated to Formica patterns and coffee shop signs. This striking design was produced in two colorways.

Introduction

"Cocktail Time," a mid-1950s Puritan Vat Print of birchbark weave, celebrates the happy hour, which was institutionalized in households across America as an anodyne for the mind-numbing commute home to the suburbs. (bottom)

Conflict between cowboys and Indians was fair game for a juvenile figural from the early 1950s, an era predating official ethnic consciousness. (top)

Flower Power

The peony-and-scroll design from Regal Puritan Mills shows the influence of mid-nineteenth century French fleur-de-lis patterns.

Cluster's Last Stand

This barkcloth, A Spectrum Original Vat Print from 1932, is exceptional for depicting pansies in an era enamored of roses, dahlias, and peonies.

Tropical Topics

With its nervous line and feathery highlights, this pattern of twining caladiums conveys the exuberant vitality of the tropical rain forest. The diamond-weave wafflecloth, available in two ground colors, dates from the late 1930s.

Yipes—Stripes

This Kandell Design on broadcloth is unique for its arrangement of tropical foliage motifs spilling over into the vertical banding.

Wish You Were Here

A surface designer interprets Paul Gauguin's Te Raau Rahi in this 1940s regional on pebblecloth. Using icons of specific geographical regions, prints such as this one would come to be considered as exemplifying the essence of Hawaiiana a half-century later.

Hurray for Hollywood

Throughout the 1920s and even into the 1930s, plumes retained their popularity. Often, as in this broadcloth from the 1930s, feathers were combined with floral elements. The peony, much beloved in the prewar period, sets the tone for the Bermudian color scheme.

This scallop-back chair wandered off the set of a 1940s Hollywood romance.

Nature Modernized

This birchbark weave from circa 1960 reveals the influence of the Scandinavian modern movement in interior design, which became the dominant idiom for discriminating and style-conscious Americans throughout the ensuing decade.

The floral and geometric textile lends character to the generic modern chair of the late 1940s offered for sale in finer department stores across the country.

From Bauhaus to Our House

The highly unusual imagery of this 1950s birchbark features stylized radio microphones and antennae expressed in an elegant palette of bold colors set off by a dramatic black background. This pattern was intended for use in a formal setting with a masculine feel.

My Boomerang Won't Come Back

Reminiscent of the "eroded" softness of Henry Moore's sculptures, the wedges and cones of this geometric print have softly rounded angles and openings. This birchbark textile was available in two colorways and dates from the early 1950s.

Science in the Home

"Nebula," a Silver Quill Fabric from the 1950s, is a whirl of all things celestial, with a twinkle of gold Lurex in the weave. (bottom)

Spectral tepees shimmer against a speckled background in this 1950s birchbark, also found in white and pink grounds with gold metallic powder. (top)

Seeming to float on air, the generic 1950s armchair combined a bulbous seating area with spindly legs.

Acknowledgments

Salvador Dali designs for the masses in this superb 1950s pattern.

Pages 118-119

This gyroscope-and-Tinkertoy print on cotton and rayon honeycomb-weave is one of the most captivating designs of the 1950s.

Page 120

Available at B. Altman in 1949, this barkcloth is an outstanding example of the organic school of textile design.

Glossary

Barkcloth • Variation of a crepe weave with a uniform "cragginess" resembling the bark of a tree. A good barkcloth uses a fat, twisted two-ply cotton yarn for density and textured depth.

Bengaline • Heavy rib-effect weave, first made in Bengal, India. The use of a coarse weft yarn (crosswise thread) such as silk or acetate gives a pronounced corded effect.

Birchbark • Flatter weave than barkcloth simulating the irregular black striations that occur on a white birch tree through the weaving of warp floats on one face and weft floats on the other.

Broadcloth • Fine, tightly woven fabric with a faint rib, usually of mercerized cotton.

Cliff, Clarice • Creator of the now famous Bizarre line of pottery produced from 1928 to 1940 for Newport Pottery in England. A prolific designer, she is known for her brash geometric designs and brilliant glazes that were immensely successful in their time and have since become valued collectibles.

Colorway • Designer's term indicating the predominant background color of a pattern.

Diamond weave • Variation of a honeycomb weave, which results in a diamond pattern woven into the ground through the use of fat yarns in the weft.

Faille • Dressy fabric using silk, rayon, or acetate yarns to weave a very narrow crosswise rib.

Ground • Background color of a fabric design, synonymous with the term colorway.

Half-drop • Styling technique for surface design. In a half-drop repeat, a motif repeats directly above and below itself; at either side a new motif is placed so that its top edge drops down to align with the center of the initial unit.

Herman Miller • Founded in 1919, this Midwest furniture company phased out its reproductions of middle-class traditional furniture in the 1930s and concentrated on manufacturing modern styles. In the 1950s, Herman Miller furniture was acclaimed worldwide as the most advanced thanks to the talents of George Nelson and Gilbert Rohde, and the exclusive rights to the molded plywood designs of Charles and Ray Eames.

Heywood Wakefield • Designer and manufacturer of household furniture from the 1920s through the early 1960s. Based in Grand Rapids, Michigan, and Los Angeles, California, this firm is known for its simple, modernistic designs crafted in blond maple.

Honeycomb • Weave that results in fabrics having waffles, diamonds, or other geometric shapes resembling a honeycomb texture.

Kagan, Vladimir • Furniture designer noted for his extravagant biomorphic shapes and his use of solid, not plied, wood in sensuous frames. Kagan did not mass-produce his seating in the 1950s, but designed for the custom trade in his native Manhattan.

Knoll International • Progressive furniture manufacturer founded in New York City in the 1940s by Hans Knoll, who initiated the idea of hiring designers on a royalty basis, thereby providing an inventory of radical new designs for the mass market by such illustrious talents as Henry Bertoia, Isamu Noguchi, and Eero Saarinen.

Linen weave • Uniform and open-spaced weave also referred to as a plain or tabby weave.

Lurex • Trademark of the Dow Chemical Corporation for metallic fibers. Silver, gold, or copper Lurex yarns were popular additions to textiles produced in the innovative 1950s.

Overblocking • Printing technique whereby primary design colors are superimposed upon a uniformly tinted ground.

Pebblecloth • Rough or granitelike surface effect achieved by using tightly twisted yarns in the weaving process.

Selvage • Edge of a woven fabric that does not ravel because the filling yarns wrap around the warp yarns. Also the area where the name of the design, the company, and the copyright are printed.

Side-match pattern • Textile styling technique in which a motif is repeated directly above, below, and to the side.

Slub weave • Uneven area in a yarn that gives the fabric made from it a high and low textural appearance.

Twill • Weave with a diagonal rib that runs from the upper left to the lower right.

Vat print • Referring to the type of dyes used to print. Vat dyes are insoluble in water and are the most resistant of any type to sunlight, washing, and dry cleaning.

Wafflecloth • Variation of a honeycomb weave.

Warp • Group of yarns that run parallel to the selvage, forming the length of the fabric.

Weft • Crosswise threads that interlace with the warp threads in a woven fabric.

Textile Mills & Design Houses

The following textile mills and design houses produced many of the fabrics pictured in this book. Most have since gone out of business, while a number have been bought up by other companies, such as Waverly.

Cofabco

Cohama Hand Print

H. J. Fabrics

Kandell Print/Kandell Design

Leana Mills

Potomac

Puritan Vat Print

Regal Puritan Mills

Saison Fabrics

Saison Happily Married Fabrics

Signature Prints

Silver Quill Fabric

Spectrum Original/A Spectrum Original Vat Print

Standish Mills

Waverly/Waverly Bonded Sister Print

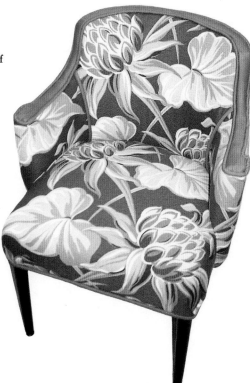

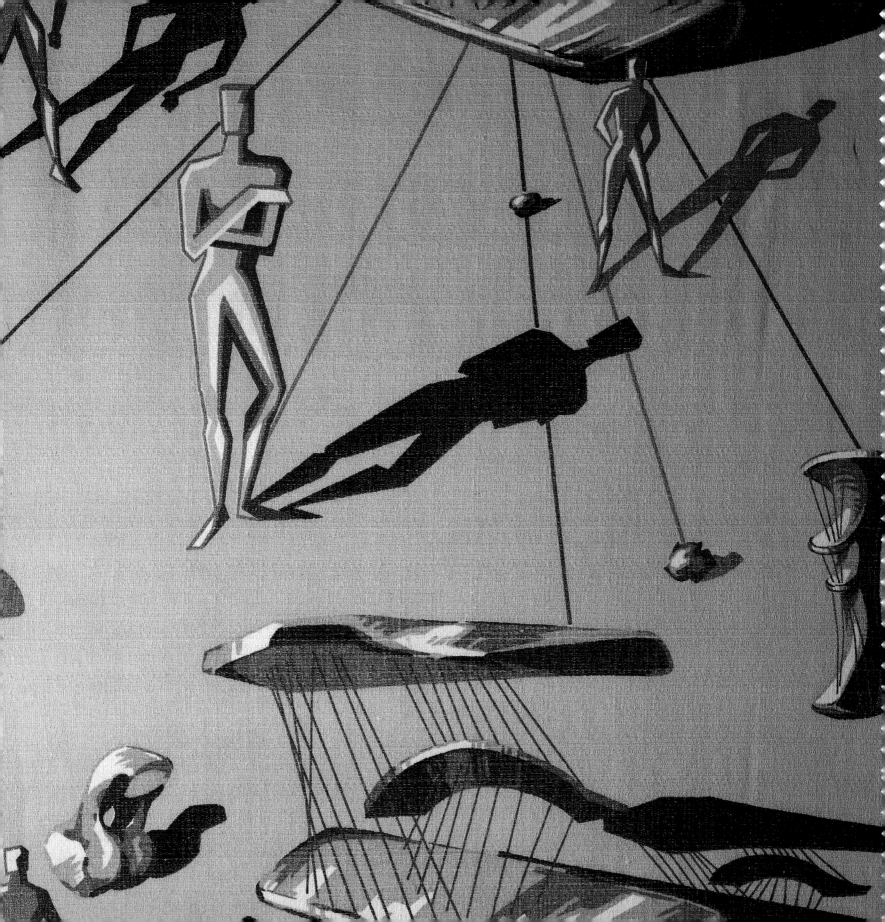

L ike most books of this kind, Fabulous Fabrics has been a collaboration among many textile archivists, collectors, photographers, writers, and editors. We would like to thank Judith Dunham for her superb, insightful review of the original manuscript and her precise comments that were so helpful in steering the text toward its final form. The contributions of textile collector-cum-archivist Patti Smith and Mary Abess of Royal Oak, Michigan, who were generous enough to donate a number of textiles that appear in this volume, are gratefully acknowledged. Special thanks go to Richard Pine, our agent, who always has had a wickedly intelligent eye for visual extravaganzas that can be communicated in book form. Bill LeBlond, our editor at Chronicle Books, not only recognized the uniqueness of this material first-hand during one of his scouting trips to Portland, Oregon, but continued to provide outstanding consultation, suggestions, and guidance throughout this project. And finally, the bottom line. As all editors and readers know in their hearts, every book has a guiding light. The guiding light steering this book to completion has been Lena Lencek, author, editor, and meticulous researcher, without whom this book would not have achieved the editorial polish it has achieved in its final form. This book belongs as much to her as it does to the authors and editors. Ms. Lencek is the silent hero behind the scenes of this project, and we thank her for her outstanding talent and commitment to the project.

Gideon Bosker

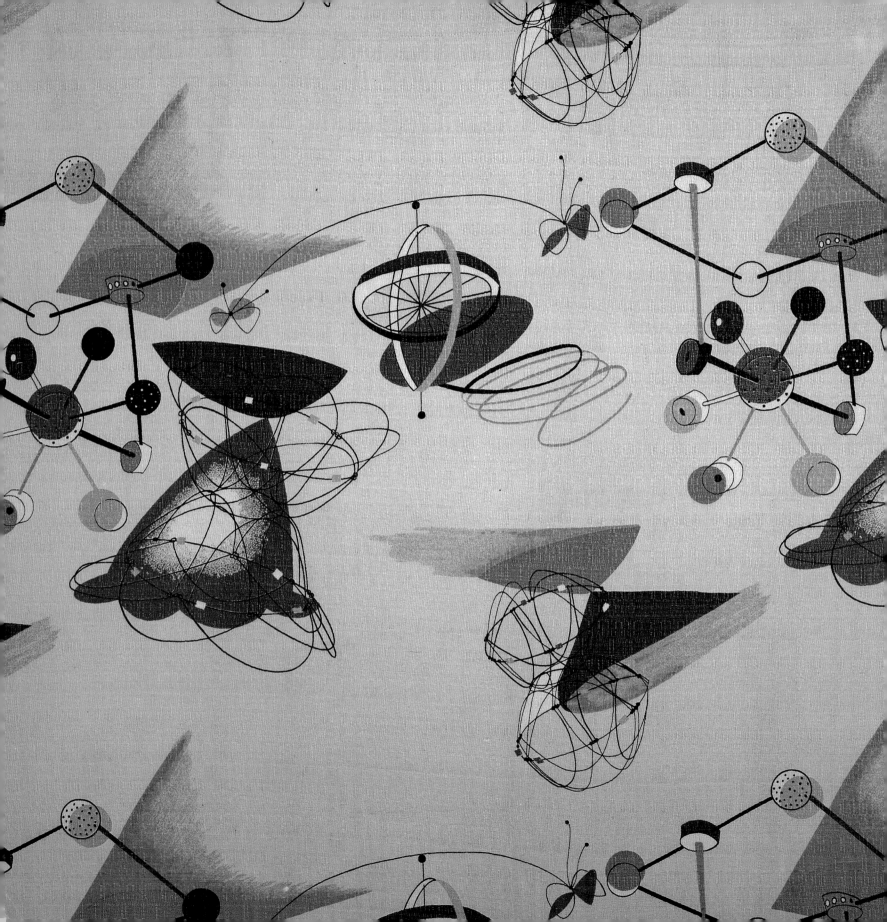

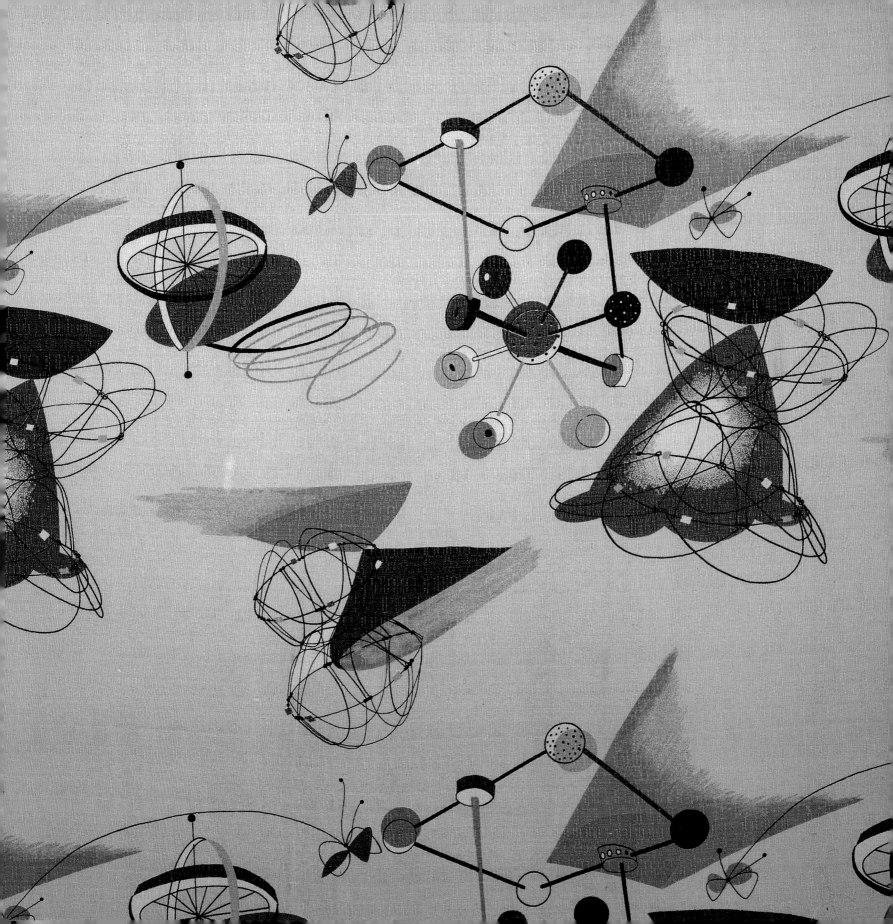